ART TECHNIQUES FROM PENCIL TO PAINT

LINE & WASH

ART TECHNIQUES FROM PENCIL TO PAINT

LINE & WASH

PAUL TAGGART

Sterling Publishing Co., Inc.
New York

Concept, text, illustrations and photographs © Paul W. Taggart 2002

Paul Taggart has asserted his rights to be identified as the author and illustrator of this work

Series concept and structure by Eileen Tunnell

© TAJ Books Ltd 2002

Library of Congress Cataloging-in-Publication Data Available

10 9 8 7 6 5 4 3 2 1

Published in 2003 by Sterling Publishing Co., Inc.

387 Park Avenue South

New York, NY 10016

First published in Great Britain in 2002 by TAJ Books Ltd.

27 Ferndown Gardens

Cobham, Surrey, KT11 2BH

©2002 by TAJ Books Ltd.

Distributed in Canada by Sterling Publishing

C/o Canadian Manda Group

One Atlantic Avenue, Suite 105

Toronto, Ontario, M6K 3E7, Canada

Printed and bound in China

All rights reserved

Sterling ISBN 1-4027-0223-X

CONTENTS

To mention Line & Wash to most artists is to immediately conjure up the popular watercolor technique. Generally this comprises of linework combined with a watercolor wash, one of the most exploited watercolor techniques, which has gained its popularity for several reasons.

Line & Wash is likely to be the technique that most artists start with when they first begin to use paint.

To develop a simple drawing by adding the simplest of color washes comes very naturally. Even if the washes are clumsy, it is the drawing beneath that holds the eye. Because of this, the application of color need not be tightly controlled, making this a less stressful experience. Even more experienced artists still hold Line & Wash dear to their hearts, for similar reasons.

The line drawing can become incredibly intricate or bold, yet still benefit from the simplicity of color afforded by it. From cartoon strips and flower painting to landscapes, the versatility of the technique has ensured its successful role in the full repertoire of watercolor techniques at any artist's disposal.

Line & Wash is certainly one of the techniques that newcomers to painting find most successful.

In any large group that I have tutored, there are few who do not gain some modicum of success, even at their first attempt in painting. In my quest to demystify the act of painting to these would-be painters, I often feel guilty for describing Line & Wash, their first introduction to watercolor painting, as line drawing with a few simple washes.

This is because the idea sounds so simple and yet there are many artists who have made it their lifetime's work. At least I can set the record straight now and say just look at what can be done with the technique.

Why should an artist not stay within a technique that offers so much and can be exploited in so many different guises, and with such varied results?

But from where does the process derive its strength and what are its weaknesses?

In watercolor, the line can be drawn with a variety of media and different tools such as pencil and charcoal or even watercolor paint itself. When the washes are applied, they should not, even in the darkest of shadows, overpower the line.

If they do, it is not some hard and fast rule that is being broken; it is simply that the result becomes something other than what can be termed Line & Wash. For when the line disappears, you have

progressed into working in pure watercolor and have moved on to other techniques.

It stands to reason, therefore, that if the lines are not to be overwhelmed, the strength of washes must be modified to accommodate for this. Pencil line and wash, having the gentlest of lines, must also have the gentlest of washes. The washes must be clean and simple, and watercolor is ideal for this, for it is always best at its most transparent. The two demands of pencil and watercolor go hand in hand, creating a perfect result.

"Can I bend the rules?" you may ask. Of course you can, for that is what painting is all about. Now that the basis of Line & Wash has been understood, there is no reason for it to be limited to pencil line and watercolor washes.

Simple color washes can be achieved with a variety of media, both conventional and the unconventional. On one occasion, having knocked a cup of coffee over and spilling its contents across a piece of watercolor paper, I noticed the drying stain took on the appearance of a landscape. Using my brush pen, I sketched into this, allowing my imagination the freedom to turn an accident into a picture!

The purpose of this book is to show how you can let your creativity loose and give you the confidence to get started in painting through the simple act of drawing enhanced by a wash of color.

I set out to show that if a "wash" can be created with an accidental coffee stain, then why not from pastels, acrylics, oils, gouache, and any of the other conventional artists media?

Just as using watercolor washes for Line & Wash is a simple, relaxed introduction to watercolor painting, so too you can use the technique to gradually introduce yourself to the other media. Working in this manner will help you attain more experience with each piece.

You don't need to be successful each time, but there is nothing more rewarding than the chance to show off an early result to friends and family. I always advise new painters to frame at least one of these early pieces, something against which they can compare later work to prove to themselves how they are developing.

Every aspect of this book is concerned with understanding the technique of Line & Wash — where the line controls structure and detail and carries the principal information, while the washes provide solidity, color, and mood.

You will find a multitude of different media and subjects to go with them. Don't rush out to buy all the materials; take your time getting to understand the vast array of media that can be exploited for this technique and the routes you can explore. Go at your own speed and use the various examples, exercises, and projects not just for the medium in which they have been demonstrated, but try them in others as well.

As for subject, these were chosen to encourage as many people as possible to take up their pencils and brushes for the first time. You may prefer something quite different once you have found a Line & Wash technique that best suits you and which you feel would be better used on another subject entirely.

Once you get started with adding a wash of color to your work, you won't want to stop and a whole new world opens up to you.

Start with simple scribbled lines, add some color washes, and see how you have entered the world of painting.

Sketch your way through a variety of figurative subjects before moving on to even more control of your linework.

Then let me show you how to control your line and strokes to exploit their descriptive qualities, before moving on to the use of directional line and strokes in achieving the form and movement of a subject.

As with all painting, it is not simply the subject and choice of media that sets your work apart, it is learning to exploit the qualities of each that can make all the difference. The simple decision of whether to let the line dominate or the color, can be crucial in the desired effect, something that I tackle in the section entitled Line or Color.

And finally, we come to the section that features a few simple compositions that pull together many of the various aspects covered in the book. These are designed to stimulate you to take up your new found knowledge and apply it to those subjects that you have always wanted to paint.

Don't let the fear of picking up a paintbrush get in your way. Enjoy what can be created with a simple scribble and a little bit of color.

MATERIALS

Watercolors

The key to bringing out the inherent beauty of the Line & Wash technique is to keep the washes simple and pure in color, to prevent the density of the wash from overpowering the character and density of the line. This does not mean, however, that you are limited in the choice of materials from which to produce these washes. This chapter deals with a variety of options and shows the basic technique of how to produce a wash using the materials described.

PAINTS
Tubes of watercolors. These semi-liquid colors dissolve quickly and evenly, enabling you to produce large quantities of fluid mixes on the palette, which are necessary to work up areas of wash.

TINTING SAUCER
Small palette for ink or masking fluid, both of which must be kept

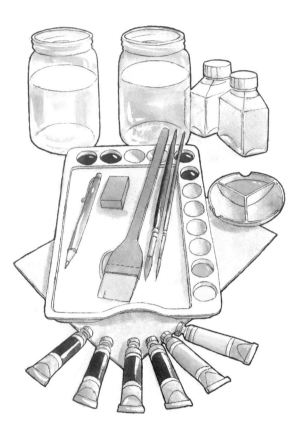

separate from paint mixes.

BRUSHES
Hake brush, made from goat's hair for wet-on-wet washes over line, does not disturb previously laid color or damage surface of paper. A round watercolor brush, sable or nylon/sable mix, is exceedingly versatile and can be formed into most of the shapes you will

need. The nylon Rigger brush for linework was created originally to tackle the rigging in sailing ships.

AUTOMATIC PENCIL
0.5mm (2B) pencil for sketching in the structure of the composition and guidelines.

KNEADABLE PUTTY ERASER
Pliable and easily molded for dabbing off pencil work and useful for

removing masking fluid.

MASKING FLUID
Latex solution for protecting areas from subsequently applied paint or linework.

WATER RECEPTACLES
Two required, one in which to clean brushes, the other kept fresh for adding to color mixes.

WATERCOLOR MEDIUM
The glue that adheres the coloured pigment to the surface. Extra can be added to thin washes for additional strength and depth of colour.

PALETTE
Features wells into which to squeeze the paint from the tubes. Central flat

area on which to mix large quantities of fluid washes.

PAPER
It is best to work with papers specifically suited for the job. A vast array of paper is available that basically fall into three categories: smooth (hot pressed), textured (Not), and rough. Each will yield quite different results, and through experimenting you will find the surface that you feel happiest working on. From the exercises in this book you will better understand the ways in which the surface works with, or against, the medium and materials being used.

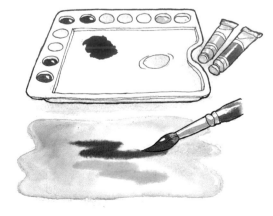

A R T S T R I P S

Watercolors
Wet-on-Dry Wash

When watercolor paint is applied to a dry surface it is referred to as painting wet-on-dry. A technique in its own right, this is, however, the most common way in which those new to painting approach the washes in the Line & Wash technique. The simplest way in which to apply color to a line and wash painting is to lay a wash across the paper, and when dry, complete the composition or study with a line drawing. Whether applying a large wash or small areas of spot color to establish detail, the key to painting wet-on-dry in line and wash is to keep the approach loose.

Mix sufficient paint to cover area. Start from top, work down, keeping brush in contact with surface to prevent blotching of paint.

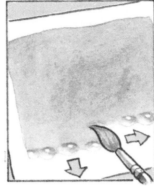

Continue down, recharging your brush when necessary.

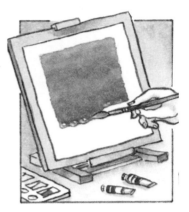

To vary, repeat technique, adding a touch of second color to mix when recharging brush.

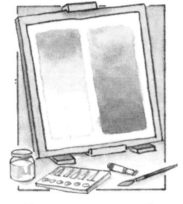

Add water to mix to produce wash that lightens gradually. Add more of same pigment from tube to darken gradually.

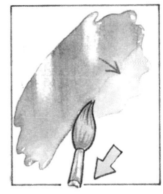

Wet-on-dry brush marks are distinguished by hard edges. These can be lightened or lost while still wet, by running a damp brush along their outer edge.

If brush is too wet, excess water will flow into colored areas, pushing pigment ahead of it — known as backruns.

Watercolors

Wet-on-Wet Wash

When watercolor paint is applied to a wetted surface, it is referred to as painting wet-on-wet. Also a technique in its own right, this does, however, offer other choices to the painter wishing to produce washes in the Line & Wash technique. The approach for working wet-on-wet is quite different and does take practice. The results are worth the time spent perfecting the technique, and early simple experiments carried out in line and wash will help to overcome any fears that could prevent you from venturing into the realms of working complete paintings in this glorious technique.

Mix sufficient paint to cover area. Wet surface with Hake brush. Keep painting brush in contact with surface to prevent blotching.

Start from top and work down, to prevent other paintwork from ruining. Use tissue to dab off any unwanted runs.

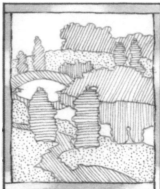

Top of painting usually portrays most distant objects. By moving forward (working down), masses can be overlapped to enforce feeling of depth.

What if paper dries before washes completed? To prevent hard edges developing...

...fill Hake brush with clean water and flick off any excess.

Re-wet surface and overlap any hard edges. Soften hard edges with round nylon brush before proceeding with washes as before.

Oils

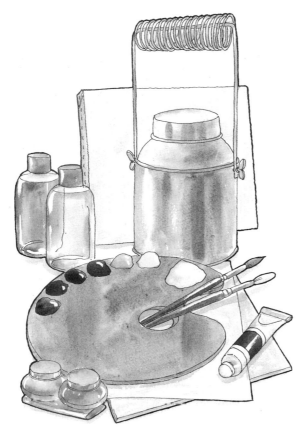

PAINTS

Start off with a limited palette of colors and experiment with color mixing. There are several ranges of qualities from which to choose, and for those new to painting, the Student's Quality is more than adequate.

BRUSHES

There are numerous brushes, in all shapes and sizes, featuring a variety of different hairs. A basic kit of one round bristle and one round nylon will keep you going for quite some time. Round brushes are extremely versatile, and while the nylon is useful for smooth work, such as linework and soft fluid washes, the bristle produces texture.

PALETTE

Flat, with a surface that is non-absorbent to oils and is non-metallic. Colors should be laid out around the perimeter and in an order that reflects the color circle. Central section to be kept clear and clean for mixing.

SURFACE

Canvas board, oil paper, or self-prepared board. Avoid stretched canvasses until you are truly confident with painting in oils.

THINNERS

Used for either mixing with paint or for cleaning brushes and surfaces. The cheaper turpentine substitute or white spirit leaves a residue of oil behind on drying. Perfect for cleaning, but not for mixes. Use purer Artist's Distilled Turpentine or odorless thinner for mixing.

DIPPERS

For storing small quantities of thinners and mediums, these clip to the side of the palette.

BRUSH WASHER

Features container to hold large quantity of cleaning agent, such as turpentine substitute. Brushes are suspended head first into cleaning agent, with end of brush gripped in spring-like handle.

MAKING YOUR OWN OILY THINNER

Oily thinners are best for washes, which need to be fluid while retaining the slow drying characteristics of oils.

Make oily thinner mix from 50 percent oil, such as Linseed Oil, and 50 percent thinner, such as Artist's Distilled Turpentine. Add to paint in desired quantity.

Oil Washes

Simple line and wash oil studies and paintings are excellent for trying out this medium, acting as invaluable stepping stones into working with oil paints. The tradition of painting in oils is in of itself based on three basic layers, in which impasto or textured paint is allowed to build up on the surface. There are, however, several stages in the painting where more fluid washes of color are used, and these can be exploited as separate techniques in their own right. They are suitable for both sketching and for more finished brushy paintings with a painterly feel.

Oil paints comprise of two principle elements. The constituent pigment, a powdered color...

....held together in a medium — the glue that binds it to the surface. Traditionally being linseed oil.

In its original tube form, the mix is balanced to produce a thick consistency that is easily worked.

This consistency is adjusted by adding a thinner (turpentine or odorless thinner) or more medium (linseed oil).

Adding oily thinner to tube color spreads out both pigment and oil to produce fluid mixes required for washes.

For sketching linework, add enough thinner to make fluid color mix that will dry quickly.

Oil Pastels

PASTELS

Cheaper sets are available in bold colors, but there are now more subtle ranges that provide a wider choice. Round or square, all have a paper sleeve to protect the fingers from the oily medium. Never remove the entire sleeve that protects the pastel stick. Peel off a portion at a time and use the end for linework and dragging strokes. To produce wider strokes, score around stick and then snap off a section.

BRUSH

A basic round nylon brush is all that is required to work both types of pastel into washes.

SURFACE

Choose a surface that best suits the work. This can range from thick cartridge paper — through tinted pastel papers — to watercolor papers or oil paper. Given that you are going to be creating washes by adding fluid to the surface, it is essential the surface can withstand this.

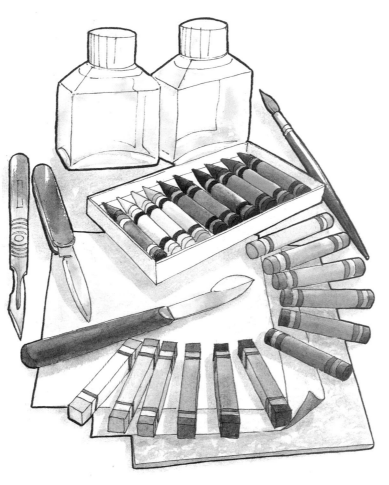

THINNERS

A thinner such as odorless thinner or Artist's Distilled Turpentine will suffice to dilute and spread the oil pastel strokes.

KNIVES

A scalpel, penknife, and erasing knife will all come in handy for various methods of scratching through layers and picking out highlights. Also for sharpening pastels where necessary.

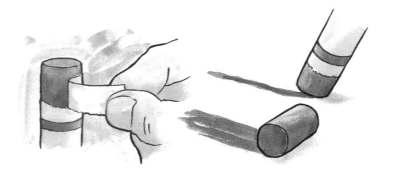

ARTSTRIPS

Oil Pastel Washes

While many would not consider using this medium, they are missing out on something that is quite versatile and potentially dramatic, not to mention inexpensive as a starting point. A small box of oil pastels, along with a round watercolor brush; a small jar of turpentine substitute; and a pocket sketchbook would make an ideal sketching kit for taking out and about with you. An all-in-one medium, that is ideal for those starting out, as they are not in the least bit intimidating — especially when using line and wash for the first time.

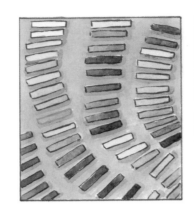

Limited Palette range means blending on surface is essential.

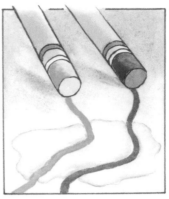

Being oil based, oil pastels are resistant to water.

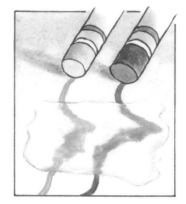

Need to be dissolved in thinners such as turpentine, odorless thinner, or white spirit.

To blend — lay over or work into each other

To blend further — use finger, soft cloth, or compressed paper wiper.

Sgraffito — scratching through layers or picking out highlights.

Soft Pastels

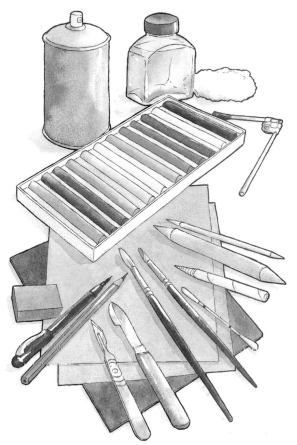

A round watercolor brush is required to turn applied pastel into pastel washes.

SURFACE

A wide range of surfaces are available, the key being to find something with a tooth that will take the pastel pigment. These include tinted pastel papers, featuring a wide variety of textured finishes; fine sandpaper; and pastel boards.

FIXATIVES

Available in aerosol form or as a bottled fluid that has to be sprayed on with a mouth diffuser.

KNIVES

A scalpel and erasing knife are essential for scratching through layers and picking out highlights. Also for scraping pastel powder onto surface to create color washes.

KNEADABLE PUTTY ERASER

The flexible nature of this eraser is essential for controlled erasing and lifting off color.

DRAWING TOOLS

2B pencil for sketching out composition and brush pen, with integral ink cartridge, complete the basic line and wash kit for pastels.

BLENDERS

There are various tools that will hep you to achieve controlled and balanced blending. Compressed paper wipers in various thicknesses allow for greater control, as do rubber tipped blenders. Cotton wool buds also work, as do cotton wool balls.

PASTELS

A considerable variety of qualities exist in the ranges of soft pastels that are available. Not all of these are as soft as you would imagine, and it is truer to say that they are more akin to hard sketching pastels. To test whether or not a pastel is soft, simply it lightly across the palm of your hand. The soft pastel will easily leave a trail of pastel on your skin. To start with go for the cheapest set you can find. Once you have decided that pastel painting is for you, switch to buying individual sticks of a better quality.

BRUSH

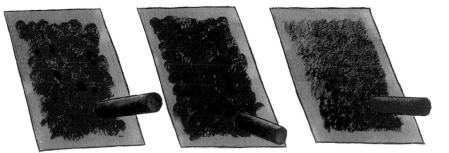

USING BLACK PASTEL

Black can be a useful color, especially when you have a limited palette, as in a boxed set of pastels. For accents (left), it brings out the surrounding color. However, if it is overdone the colors become dirty (middle). Far better to first block in the black values and then overlay with color (right).

ARTSTRIPS

Soft Pastel Washes

The notion of turning soft dry pastels into washes is not one that would spring immediately to mind for many. However, as pastel sticks are basically constructed from dry powdered pigment loosely held together in stick form with a gum that dissolves in water, there is no reason why the powdered pigment cannot be dissolved into a wash. This can be achieved in several ways, either on the palette or on the surface.

Draw image in waterproof drawing ink.

Apply pastel in required areas, bearing in mind that it will be partially dissolved and will spread.

Use wetted round watercolor brush to spread colors up to edge of linework. Don't be tempted to smooth out all pastel. Retain mix of smooth wash and texture for interest.

Applying water thins out pastel, allowing linework to show through.

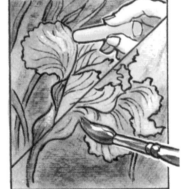

Leave to dry, before adding lighter colors using same technique.

Adding only water ensures pigment retains its intensity. Mixing with a gum medium will dull color, but fixes it.

Inks

INKS

Drawing inks and colored inks are now available in a fairly wide range of colors and in waterproof and non-waterproof varieties. Some ranges of ink come with an integral dropper in the screw top lid; others do not, and a separate dropper is required to control the amount of ink being added to the water when making up washes. Ink is a powerful staining agent, and washes need to be carefully mixed to create different intensities.

DRAWING & TEXTURE TOOLS

Dip pens, bamboo pen with integral brush head, reed pens, and old toothbrushes are just some of the tools that can be used to provide line and textural effects.

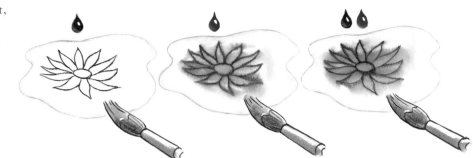

WATERPROOF OR NON-WATERPROOF INKS?
Once dry, waterproof inks (black in diagram) can take washes without being disturbed. However, the non-waterproof inks (blue in diagram) begin to spread and dissipate, creating exciting stains. Mix the two and on wetting, one stays in place fixing the line, while the other runs, creating tone and texture.

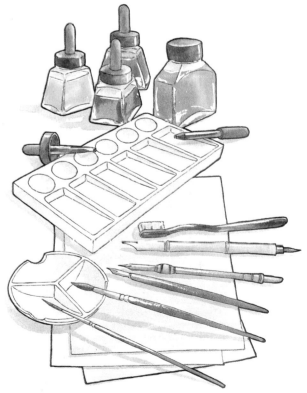

BRUSHES

Two are essential for ink line and wash. A round nylon watercolor brush for washes and a nylon Rigger for linework.

PALETTES

Since inks stain, it is essential that palettes are non-absorbent, preferably ceramic. For color washes, the rectangular variety is ideal, with round wells for holding undiluted ink and slanted long wells for diluting with water into washes.

A segmented ceramic tinting saucer is useful for holding linework ink that requires dipping in of Rigger brush, pen points, etc.

SURFACE

Watercolor papers, smooth thick cartridge papers, line and wash boards, and Bristol board provide a variety of surfaces and finishes, all of which affect the texture of both the line and the wash.

MASKING FLUID

Used for masking off areas that require the original color of the surface to show through or provide highlights. An essential tool, as lifting off dried ink is very difficult, if not impossible, without damaging the surface.

Ink Washes

Unlike paints, inks stain the surface on which they are applied, rendering them much more difficult to remove. They are, however, extremely versatile and can be used both to provide color washes in their own right or underlying washes of tone — against which subsequently applied transparent washes can work to add depth to the painting.

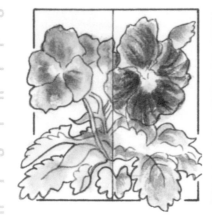

As ink line is strong, washes can be applied wet on wet (left) or wet on dry (right).

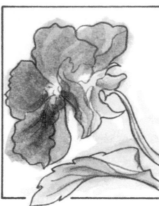

Loosen up application of color — don't feel washes need to be restricted by outline.

Extend your approach, by varying line color throughout...

...to echo color of washes to come.

Tonal ink wash beneath color washes holds colors together and adds contrast that increases depth of painting.

For base washes, mix a few drops of waterproof drawing ink with a large quantity of water in a separate small saucer palette.

Masking Fluid

A rubber latex solution, masking fluid should be considered as a colorless paint, that is applied to protect areas from subsequently laid areas of color. As such, its application has to be approached in exactly the same manner as you would paint, with thought as to its placement and care as to its application. The edges of a masked area are always sharp. In watercolor these edges can be softened later, but not so in waterproof ink.

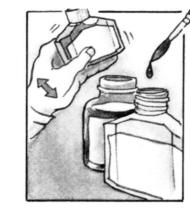

TIP: add a few drops of drawing ink to the bottle of masking fluid and shake well before use. This will enable you to see the mask on the surface.

Shaking will make solution frothy. Pour small quantity into sectioned ceramic palette and allow to settle before using.

Never allow masking fluid to mix with wet paint; otherwise, it will coagulate and clog both brush and paint mix, rendering both unusable.

Always apply to dry surface; otherwise, it will infiltrate fibers and cannot be removed, rendering the surface unusable.

Ensure paint layer is completely dry before removing mask, or it could smear into painted areas. May also tear surface.

Best not to leave mask on for longer than 24 hours. Removal becomes more difficult the longer it is left.

Introduction

The notion of controlling color mixing can seem tedious when you really want to get on with painting. It can, however, prove endlessly rewarding — for not only is it important in your work, but it will open your eyes to the delights of color in everything around you.

How often have you seen the colors in a sunset or the dazzling clarity of fireworks against the night sky and desperately wanted to capture that moment forever? Cameras seldom do justice to such colors, for it is not the color alone that evokes our emotions but the context into which it fits. Obviously, it is essential to know how to mix and mimic a color exactly, but it is the colors all around that will make it work.

Unlike a photograph, the artist can balance colors and values throughout an image, but to do so must be able to control the colors as they flow across the composition.

It is certain that once you begin to understand colors you will see more in evidence all around you. While it is stunning to everyone to see sunlight filtering through the leaves of an autumnal tree, you will eventually get as much of a thrill from looking closely at a gray sky, through knowing how to mix colors for yourself.

Gray is not simply the neutral color we think of when black is mixed with white. Inside a cloud, for instance, gray can be warm or cool, with dull oranges or dull blues.

On a journey to the Highlands of Scotland, we did not see a hint of sun during the drive. To top it all, the trees were bare of leaves and you would imagine that such a trip would have been colorless. Instead, we were overawed by the color. Many limbs of the trees were a deep, lustrous red and were set against the multi-hued heathers, lichen, mosses, grasses, and stones that covered the ground in endless patterns as far as the eye could see.

It is the interplaying of subtle colors such as these that can turn your work from the ordinary into the extraordinary. By getting to grips with color mixing for yourself, you will soon find that a simple set of six colors is all you need to produce a rainbow of possibilities.

TERMS ESSENTIAL TO UNDERSTANDING COLOR MIXING

HUES

Bright primary and secondary colors are known as hues.

VALUE

Some hues are very light, while others are dark = different values.

INTENSITY/CHROMA

Dull colors have a lower intensity than the bright ones.

TONE

The degree of lightness or darkness of a neutral gray.

COLOR MIXING

Where the prefix letter is shown in capitals this denotes a larger quantity of that particular color.

Conversely, where the prefix letter is shown in a lower case, this denotes a smaller quantity of that particular color.

E.G.

Bp= large amount of blue-purple.

bp = small amount of blue-purple.

COLOR REFERENCE

Red-purple (Rp) i.e Crimson Red

Red-orange (Ro) i.e Cadmium Red

Blue-purple (Bp) i.e Ultramarine

Blue-green (Bg) i.e Prussian Blue

Yellow-orange (Yo) i.e Cadmium Yellow

Yellow-green (Yg) i.e Lemon Yellow

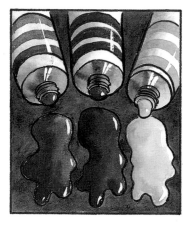

Primary colors: red, yellow, blue cannot be created by mixing. Only available directly from tube.

These three primaries mix to produce secondaries.
Red +Yellow = Orange.
Blue + Yellow = Green.
Red + Blue = Purple.

In theory these colors make up the color circle and are known as hues. Hues area all very intense (bright).

Sometimes, mixture of two primaries produces dull secondary, i.e. Prussian blue + Cadmium red = gray.

In practice two of each primary color is required to make up secondaries. Red-orange [Ro]. Red-purple [Rp]. Blue-purple [Bp]. Blue-green [Bg]. Yellow-green [Yg]. Yellow-orange [Yo].

Close primaries mix to create bright secondaries. Ro+Yo = bright orange. Rp+Bp = bright purple. Bg+Yg = bright green.

Distant primaries produce dull mix, i.e. Ro+Bg = dull colored gray. So each primary is biased toward brightest secondary it can create.

Try out distant primary mixes as an exercise. Ro+Bg. Rp+Yg. Bp+Yo.

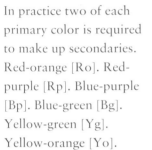

Complementary colors appear opposite each other on the color circle.

Being opposite, they contrast against each other when placed next to/over one another.

Mixed together they produce gray...

...because by mixing all complementaries, all primaries are mixed together, which theoretically produces black.

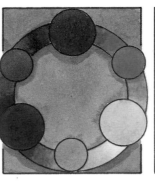

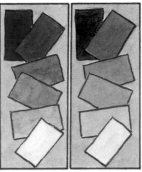

Mixing complementaries is equivalent to mixing all the primaries, which creates a very neutral gray.

Color can change in hue. Red changing to purple or orange is a change of hue. All hues around outer color circle are intense (bright).

Color can change in tone (value), lightness or darkness of color. Left = graded values. Right = color tones.

Color can change in intensity, strength, or brightness. Decreasing intensity from left to right - also known as chroma.

Adding white (tint) in oils (left) or water in watercolors (right) lightens color. This also makes the color dull, as it decreases the color's intensity and value.

Adding black to either creates a shade and darkens the value. But it also dulls the color and often changes its hue. Try adding black to yellow and you will produce green.

Adding a darker color changes the value and the hue. Above, color becomes darker, but also green. If we could eliminate the hue, the change of tone alone would be seen.

Adding a complementary dulls and darkens the color. Here the hue does not change, but the intensity and value does. This is an important color mix.

Adding a complementary and (a) white to oils [left] or (b) water to watercolors [right] changes the intensity only, eventually creating grays.

To change a color you can therefore move through the hues by moving around the color circle or...

...change its value and intensity by adding it's complementary...

...change its intensity alone by adding its complementary and (a) white to oils or (b) water to watercolors.

How to start to mix a specific color?

Firstly find it's hue, i.e. what color is it? This exercise is based on a deep blue-green tree — the pure hue is very intense and too dark.

Secondly, decide on its value.

If your initial hue [top left] is too dark in value, you can add water [for watercolors] or white [for oils] to the mix.

A R T S T R I P S

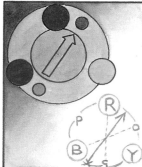

If the value is too light, you can add more pigment [hue] to the mix.

If the pigment [hue] itself is not dark enough, a complementary color is required. This will darken your color while not changing its hue.

Find the complementary by looking at the opposite side of the color circle. You can see how a simple hand-drawn color chart will furnish the answer [bottom right].

Thirdly, decide on its intensity...

...and add it's complementary until you achieve the correct intensity [chroma].

Eventually this balance between hue, value and intensity brings you to the exact color mix. Experiment with some different mixes.

NOTE: Although browns are natural earth pigments, they can be mixed from warm colors by adding their complementaries.

All colors have warm and cool associations, and the color circle is therefore loosely divided into warm and cool colors.

Introduction

Most people think of scribbling as non-artistic, something that everyone can do, which is of no real merit. Something to while away the time when you happen to have a pencil or ballpoint pen in your hand. No one would expect a scribble to find its way into a frame and be hung on a wall.

Yet, that carefree feeling you have while scribbling is the one to which most artists aspire when creating very serious works of art. We love children's drawings and paintings because they are unpretentious in exactly the same way. Produced for fun, they convey the spirit of the subject no matter how removed from a photographic representation they become.

How are you to place yourself in this state of mind?

Firstly, you must remove all feelings of responsibility. By that I mean you must not think of what other people expect. Be it family or tutor, they are ultimately unimportant. You are creating for yourself.

Timescale is of no importance, either in the length of time taken to produce a single piece of work or in the speed of your development.

What Is Important Is That You Enjoy The Pursuit And It Gives You Satisfaction.

That doesn't mean it will be easy, for true satisfaction only comes in overcoming obstacles and improving your skills.

You must give yourself time to develop and be forgiving of yourself. Everyone makes mistakes; even professionals started somewhere and continue to make mistakes. Mistakes are an important part of the learning process, so you should never be burdened with them.

Set aside some time, find a quiet place to work, and prepare yourself by relaxing. Place a piece of paper in front of you, pick up a pencil, and make a mark or two. Continue to cover the paper without worrying about every line. Soon, you will have begun to evolve these marks into some sort of structure. This is scribbling and your mind is now open, allowing you to enjoy the process without worrying about the end result.

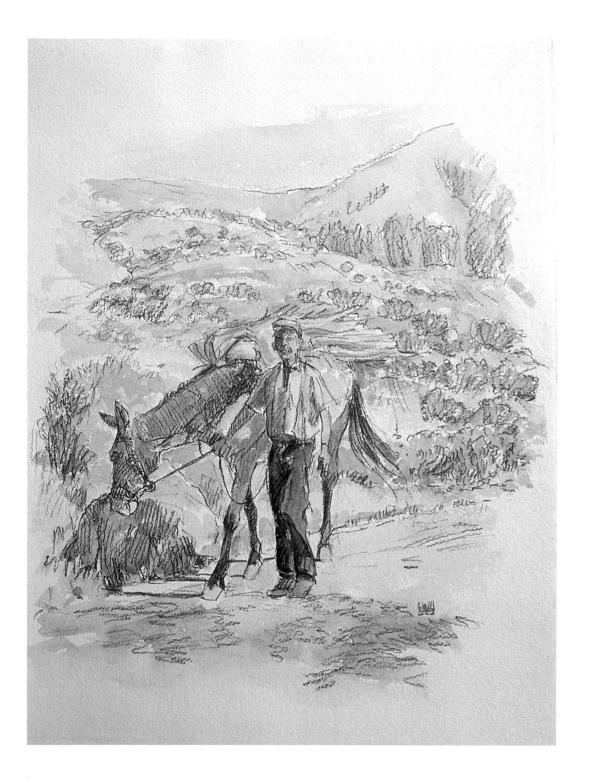

MATERIALS

HB, 2B Pencils

Watercolor Paints

Acrylic Paints

Acrylic Inks

Waterproof Drawing Ink

Oil Pastels

Brush Pen with Integral
Ink Cartridge

Bamboo Brush Pen

Round Watercolor Brush

Rigger Brush

Hake Brush

Sketchbook with
Watercolor Paper

Watercolor Paper

Handmade Paper

Masking Fluid

Kneadable Putty Eraser

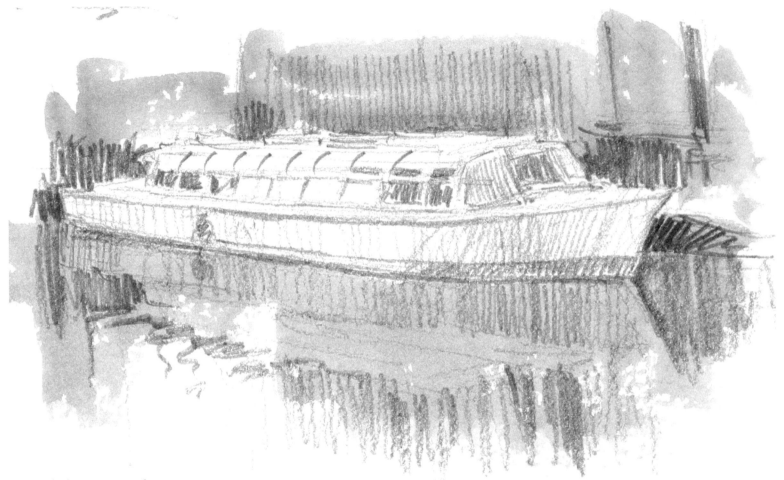

Pencil & Watercolors

For most people the first steps into using paint involve adding a touch of watercolor to a pencil drawing. Often the simplest of techniques are the most rewarding, and here the gentle pencil linework and line shading are complemented, rather than overpowered, by the watercolor wash. Colors are kept to a minimum and by painting the background only around the object, the drawing of the boat is isolated, focussing our attention away from the complexities of the architecture and reflection that surround it.

Subject focus achieved by simple color added to background only.

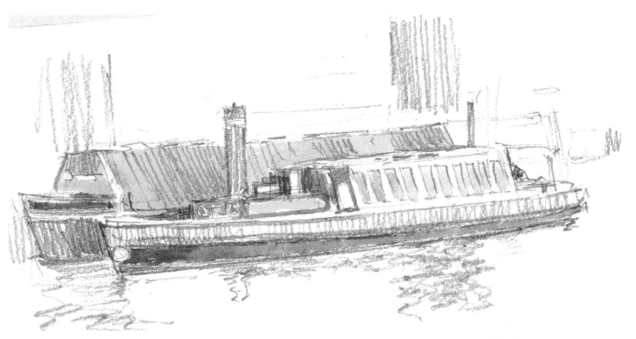

Subject focus achieved by simple color added to object only.

Carry a small hand-held sketchbook to capture reference scribbles.

Establish principal outlines in pencil directly from subject...

...with spot color added in situ.

The object itself may have colors that demand our attention. Here, a similar subject is allowed to carry some of its more exciting colors. Once again, the trick here is to avoid overworking. An artist's task is always to select the elements that excite and stimulate. Through selection we focus on and communicate what pleases us. Therefore, even the strongest of color washes is kept well beneath the strength of the pencil linework, which carries all the information. Color used in such a way can be such a pleasure, for it is not used structurally, but simply as a means to lift the line and solidify the shapes.

Brush Pen & Acrylics

It is preferable when applying ink linework to work with waterproof ink so that subsequently applied washes do not dissolve the line. Both of these studies are overpainted with simple acrylic washes. As with watercolor, the acrylic washes can be applied both to a dry or wet surface. By carefully looking at the edges of the washes, you will be able to tell which process was used. Where they are soft, the surface being painted was wetted first (restricted wet-on-wet); where hard, the paint was applied to a dry surface (wet-on-dry).

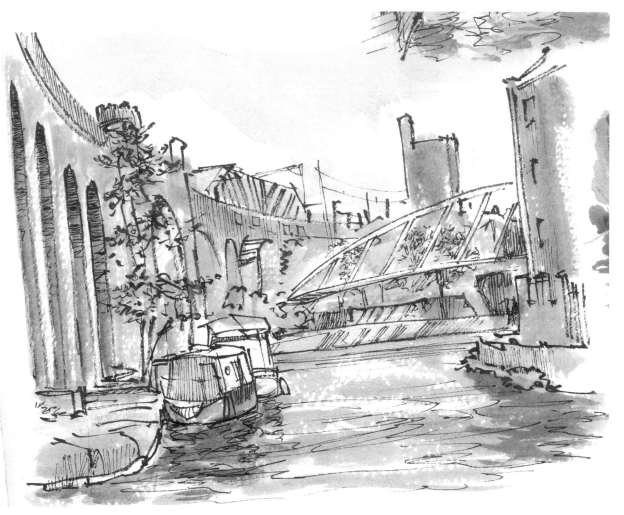

BRUSH PEN & ACRYLIC WASH
While pencil linework can engage your imagination for some time, you will inevitably gain enough confidence to increase the strength of the color washes. Thus, your pencil linework will eventually be overwhelmed by the color. Should you wish to retain the line, then it must be strengthened, and using ink is a natural response to this dilemma. While there are several tools with which to apply ink line, the brush pen is very convenient for working on the spot. It carries its own ink supply in an integral cartridge and is easily slipped into your pocket or bag. Here a complex city canal scene is simplified through the fluid linework of the brush pen.

Vary angle, pressure, and speed of application to establish a variety of line qualities.

Brushy hatching can also be varied and offers scope for creativity.

Swiftly apply simple washes of color with a round brush, using either watercolor or acrylic paints.

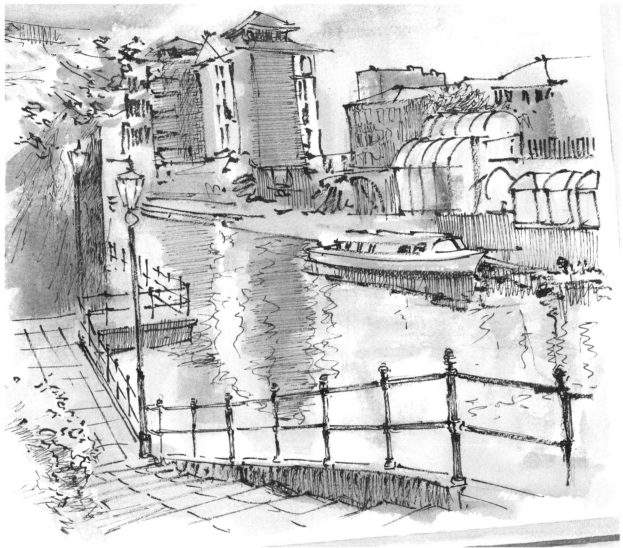

BRUSH PEN & ACRYLIC WASH

A twilight view of this subject was particularly stimulating, with the warm colors of the sky and artificial lights seen against the cool blues of the encroaching shadows. The swiftness of line afforded by the brush pen allowed me to interpret the essence of the scene in the short time available.

Rigger, Ink, & Watercolors

RIGGER & INK LINEWORK WITH WATERCOLOR

This line and wash sketch is started off with an initial pencil sketch, laid lightly onto an unstretched piece of rough watercolor paper. The linework is then established as a simple silhouette with waterproof drawing ink, drawn with a Rigger brush. The minimum of line at this stage allows the subsequently applied watercolor to provide the masses on which to build more linework. The line is made to fade away as it reaches the edges, to focus on the central feature building. Add water to the ink or decrease the pressure to achieve this effect.

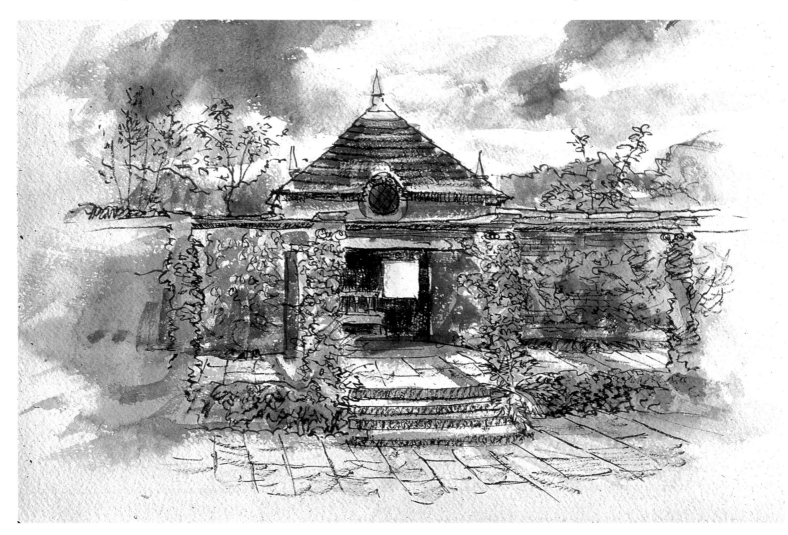

Some highlights are protected with scumbles of masking fluid. Once dried, initial watercolor washes are laid over using the Hake brush and a round watercolor brush in bold, confident strokes. The very edges of the composition are "lost" to further enforce the vignette effect, begun by the fading linework applied earlier.

Once the first layer of washes is dry, the masking fluid is removed and a second layer of color is applied to create textures and darker accents of tone using the round brush.

The whole line and wash composition is finished off by reverting back to the rigger and ink to reinforce detail and introduce line shading and scuffing to create texture. It is crucial not to overwork this, nor fill in areas where the color is doing its job.

What is apparent from this sketch is the fact that the washes need not be contained nor controlled, as they are used to create an impression — with the linework doing the job of providing detail and focus.

Hold Rigger brush lightly to sketch minimum of line that describes silhouette. Once dry, erase pencil work with kneadable putty eraser.

Transparent color can be boldly and loosely applied with a large brush such as a Hake.

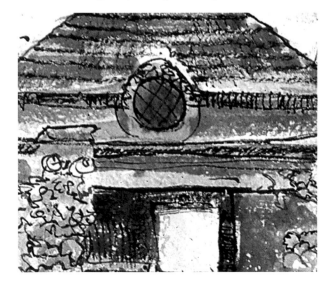

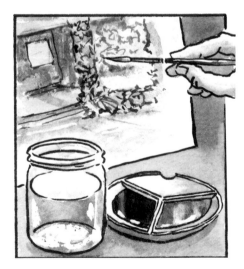

Extra linework finishes off the composition. Dilute ink to suggest distance in background. Reduce detail toward edges to strengthen vignette effect.

Oil Pastels

On first inspection, oil pastels seem a little crude. They do, however, present a totally different sort of line with which to experiment. There is no doubt that application of detail is difficult, but this ensures that your approach will remain loose and scribbly. The fact that they can be manipulated by softening, or scratching them off, does allow that element of control, which makes them an essential and inexpensive tool with which to work.

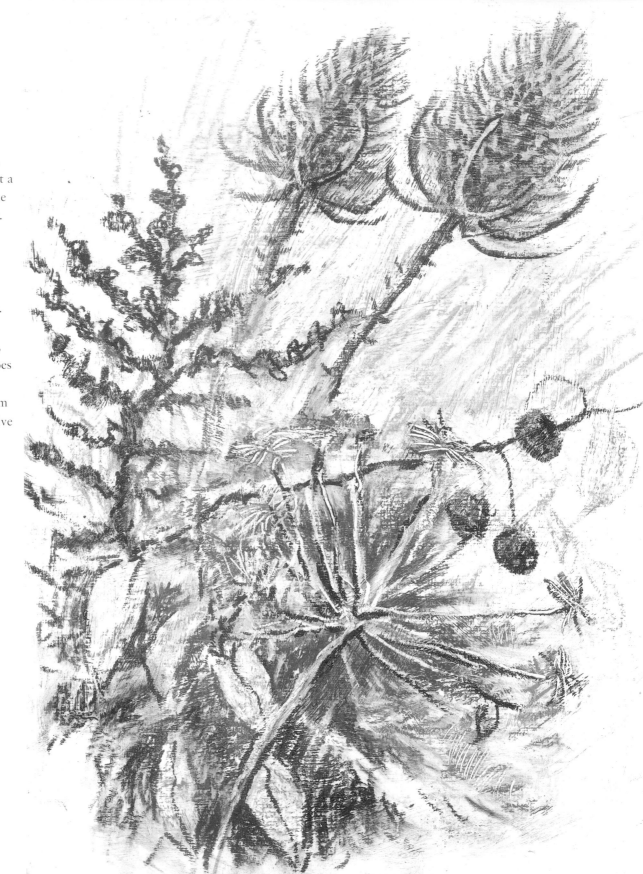

Here a simple bunch of dried flower heads and seeds provides ample scope to test out the creative possibilities of a limited color range of oil pastels. Linework is achieved through both drawing with the pastel and scratching through laid colors. Washes are achieved by softening applied strokes with a brush and thinner.

Prime a piece of scrap cardstock using white acrylic paint or PVA glue.

Oil pastel can be applied dry or onto a pre-wet surface (wetted with thinner such as turpentine).

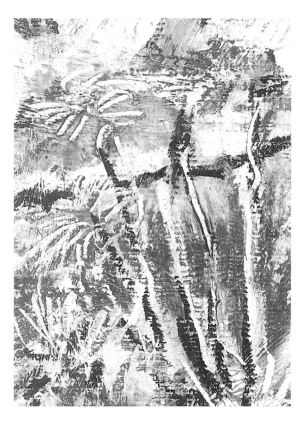

Oil pastel can be smeared with thinner and brush (top) or scratched through with knife (bottom).

Bamboo Brush Pen & Acrylic Ink

The boldness of the bamboo brush pen strokes is immediately apparent. [Left column] pen was used conventionally. [Right column] using reverse of pen point produces finer line. Note the marked contrast between a well-loaded tip and one that is depleted. When heavily loaded the stroke is almost brush-like, but becomes gentle, almost pencil-like, as the ink dries out on the pen point. This can be controlled by loading the pen and then gently wiping off excess fluid with an absorbent tissue.

With no preliminary drawing, this rendition of a piece of coral is truly "taking the line for a walk." Allow the form to "grow" from the base so arms can overlap naturally. The bamboo pen produces a sufficiently brittle line to emulate the characteristics of this coral, which is rendered here in a dark-brown acrylic ink. The seed impregnated handmade paper was selected to introduce further characteristics: the hairy seeds resembling zoanthids (close relatives of the stony corals). Being very absorbent and textured, the surface demands short stabbing strokes with the pen. Apply warm-brown ink wash on right side of background to provide foil for lit areas to work against. Add dark-brown of line color to the wash and apply this mix to create shadow on coral itself. Use Hake brush to prevent fussing and work in broad strokes. Once all dry, lines on the left side of the work are strengthened and made more descriptive by using the back of the pen point.

MATERIALS

Bamboo Brush Pen

Acrylic Ink (dark brown & warm brown)

Seed-impregnated Handmade Paper

Candle (white)

Hake Brush

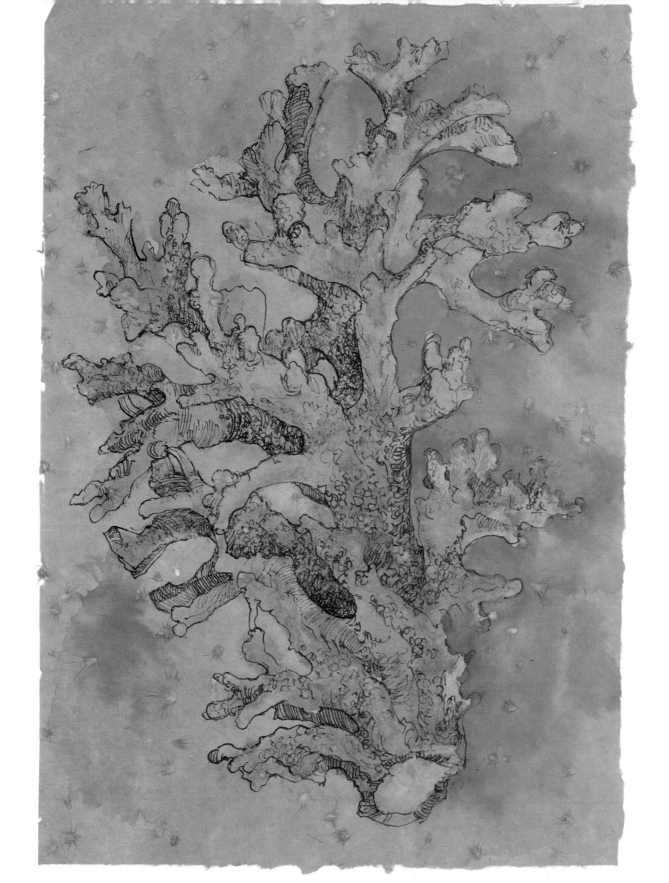

Introduction

Sketching involves the important process of gathering information, either for more detail work in the future or simply as an enjoyable end in itself. As such, a sketch does not need to appear finished. Spontaneity is the essential factor here, and focussing on the line can provide this quality, providing you are using your medium in a fluid fashion.

You may decide to use a dry medium such as pencil; a wet medium such as ink or felt tip pen; or the point of a knife, for layered wax crayon work. As long as your approach is loose and relaxed, what you choose as the drawing tool is entirely up to you.

By scribbling in the first place, you will have learned to go with the flow, to enjoy the process of making marks. Sketching requires a little more attention, as a planned approach is needed.

This planning may involve the decision as to what subject you wish to sketch there and then, or for what future paintings you are gathering reference sketches. On the other hand, it may simply be that you wish to fill a sketchbook with drawings that you can look back on in time to come, perhaps sketches of a holiday, of family and friends, of family pets, views from around your house and in your garden — all of which you wish to execute in quickly drawn sketches that capture the moment.

Even though sketching requires a little more thought, don't let this inhibit your enjoyment of it. The sketchbooks of mine that I view with the most nostalgia are battered and bruised, and their pages coffee stained and smudged. Evidence that I often got carried away when filling their pages.

Extend the reference gathering experience and fix other items to the pages, a pressed flower or leaf, a feather, the bus ticket that got you to the scene, and the odd snapshot. Building up a collection of sketchbooks stuffed with drawings and other memorabilia can provide every bit as much enjoyment as producing fully finished drawings and paintings to hang in frames.

MATERIALS

HB, 2B Pencil

Charcoal Pencils

Watercolor Pencils

Sketching Pastels

Wax Crayons

Felt Tip Pens

Waterproof Drawing Ink

Colored Inks

Watercolor Paints

Large Soft Watercolor Brush

Chinese Goat Hair Brush

Rigger Brush

Kneadable Putty Eraser

Sharp Knife

Heavyweight Artist's Cartridge Paper

Watercolor Paper

Raw Silk Paper

Don't limit you sketching to one drawing tool and one single color. Often you will find that when working in one medium, it will suddenly occur that the approach and technique could also be adapted for use with another, such as charcoal or crayon.

Keep all your options open. What is marvellous about drawing and painting is that you will never know it all and thus will never run out of new possibilities for the future.

While it is wonderful to produce a successful work, we do, however, learn more from failures. So be prepared to have another go and don't become disillusioned, because along the line everything will fall into place.

Working out answers to some fundamental questions will help you to develop and move on. What has worked well for you and what has not? Having made a complete mess of something, has it made you aware of where it went wrong? Could you approach a different, but similar piece with more chance of success?

Felt Tip Pen & Inks

[A] Work on as large a scale as you can manage so that the fluid felt tip strokes are not intimidating. Any smooth paper will do. This sketch measures just under 19" x 12" (475mm x 300mm).

[B] Gently sketch out main outline of composition. Overlay with one color of felt tip pen — in this a dull yellow was used. It is tempting, but dangerous, for the balance, to use too many colors at this stage.

[C] Apply warm ink washes to sunlit areas using a large soft brush.

[D] Cool purple ink washes provide the contrast for cool temperature shadows.

[E] Mixtures of the same warm and cool inks provide alternative colors.

[F] If the felt tip pens do not contain permanent ink, ink washes need to be applied fluidly and with speed. Here the resulting dissolve of the previously applied linework adds to the character of the drawing.

[G] Apply final linework in two colors only. Here I used dull orange and purple (warm and cool colors). This sort of drawing is full of perspective, but don't let that frustrate you. Concentrate on the design of the shapes, and how they interlock and overlap. Remember that you are not going for accuracy, but an impression of the scene.

TIP

When using felt tip pens to produce sketches that you wish to keep, it is essential that you choose a set that are lightfast; otherwise, the sketch will rapidly disappear.

Charcoal Pencil & Sketching Pastels

[A] White cartridge paper provides a smooth surface for the charcoal. On a more textured surface the charcoal will illuminate its irregularities and can impinge on the drawing.

[B] Apply a gentle pencil outline of the main composition. Then apply soft pastel washes throughout. To do this, wipe the pastel across a cotton wool ball and use this "colored" ball to apply the wash. Small areas of color wash are applied using a cotton wool bud.

[C] Reinforce the line with a medium soft charcoal pencil.

[D] In places, the charcoal line is softened along its length by blending with a cotton wool bud.

[E] Stronger line and hatching is applied to consolidate and focus.

[F] Necessary highlights are re-established by dabbing out with a kneadable putty eraser.

[G] The more controlled structure and diversity of linework makes this a line and wash sketch rather than a scribble.

E A F B C G D

Watercolor Pencil & Watercolors

These two sketches were completed first as
a gentle watercolor wash over a pencil
skeleton, finished off using watercolor
pencil. The latter provides line, accent, and
texture across the raised surface of the
watercolor paper. Specific areas of
watercolor pencil can be softened with a
damp brush and become richer in color as
the pigment spreads in the small deposits of
water. Note how the line along the
silhouette of each figure can either be gray
or a color, reflecting the subject.

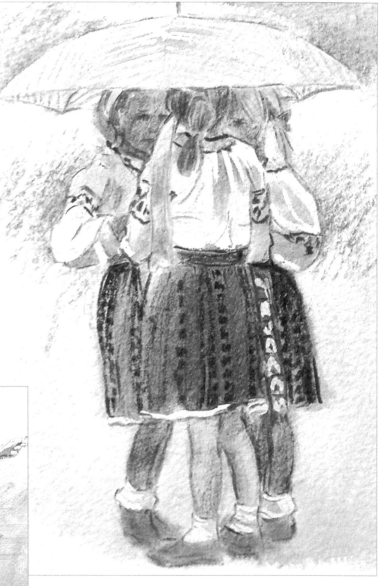

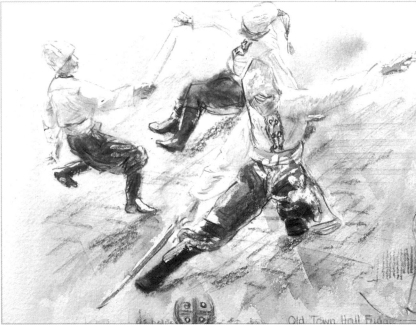

HORIZONTALS, VERTICALS, AND DIAGONALS

Here we have two subjects that are almost identical in their method of creation and yet feel quite different. Both are loose and yet the dancers have more dynamism. The reason is soon apparent when you study the grid representing the general layout of form and structure.

The dancers are based on a diagonal format, as opposed to the vertical format for the group of girls. Horizontal and vertical elements tend to lend the composition a static, calming influence. Diagonals, on the other hand, are disturbing to the equilibrium. They suggest movement and instability. Even the strokes on the ground follow this diagonal sway, and so we feel that everything is in motion.

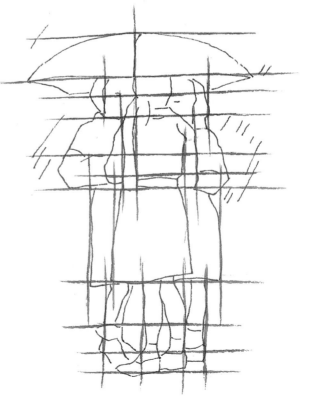

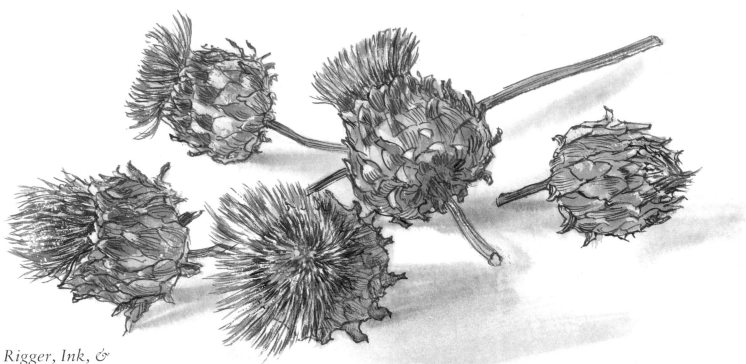

Rigger, Ink, & Watercolors

The Rigger brush was created to handle linework, specifically the portrayal of fine rigging in sailing ships. A sensitive and responsive brush that you may at first find a little daunting, will soon, after only a little practice, become one of your most valued tools. Available in sable or nylon, I prefer the latter for that extra bit of bounce or "spring" in its fine point.

In this sketch the ink line it provides shows up against even the denser areas of the watercolor washes. We are now beginning to achieve a perfect balance between the line and the color. The latter can now have a range of values that help to create volume and light so that even in a simple sketch, such as this, there is real depth within the picture surface.

The brush line has an inherent range of qualities, depending on pressure, direction, and speed of application, which can be used to respond to the nature of the subject.

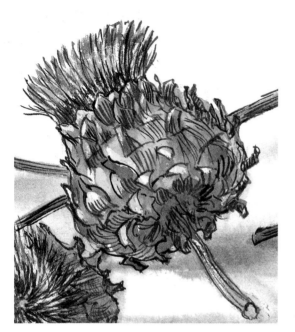

Sketch silhouette only, with fine point of Rigger brush and waterproof black drawing ink.

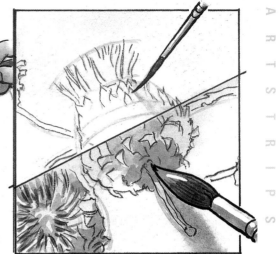

Draw minimum of detail inside seed head to allow watercolor paint to fulfill its role.

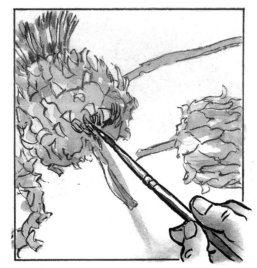

Once dry, apply line textures and shading as simple hatched strokes.

Wax Crayons

It may seem a little tortuous at first to select wax crayons as a medium to render such a delicate subject. After all, children use these most basic of crayons in school and they seem less than delicate. You will, however, be surprised by what can be achieved in building up layers that are then scratched through, providing a fine hatch of colored linework.

Here the light-colored layers are "washed" over with a heavy layer of gray, which at first seems to obliterate the color. However, scratching through with a sharp, curved blade reveals bright lines and strokes, which can be finally accented in black or a dark color. The final black can be interesting, as it responds to the carved surface over which it is worked. This technique is something with which you can spend time experimenting to create your own individual style of sketching.

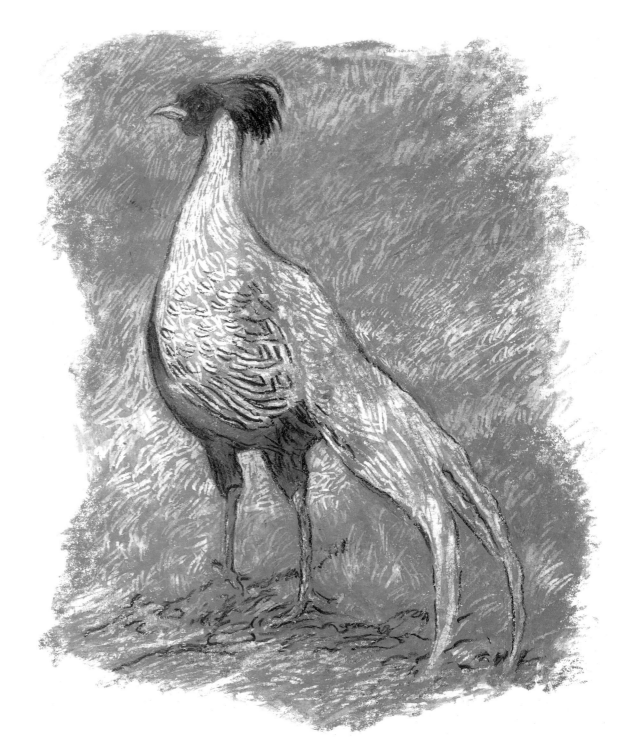

With pencil gently sketch in basic outlines on to thick paper or cardstock.

Work on colors, mixing on surface with overlaid strokes (bottom). Heavily block on mid-gray over whole surface (top).

Use curved blade to scrape or scoop strokes of color through overlaid gray.

Add finishing touches with black crayon.

Chinese Brush & Inks

A Chinese Goat Hair brush was used for the painting. When wet, these brushes "droop" so it is better to hold them vertically.

Keep the painting flat and take up a relaxed position.

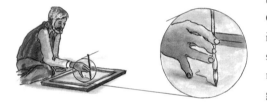

The brush can be steadied by "skating" the tip of the small finger along the painting surface.

Variation of pressure on the brush easily changes line thickness, achieving a wonderfully descriptive line.

To create an unusual surface on which to create this sketch, a piece of watercolor paper was stretched and painted in dark colors. Once dry, a layer of silk paper was glued to the surface using PVA glue, this representing the shimmering water and seaweed against which to set the fish. A soft, gentle pencil outline establishes the position of the fish. The surface is soft, so overworking or excess pressure can easily cause damage. A colored gray mix of inks is used to block in the outlines, using the Chinese brush. Unmixed ink colors applied in bold brushy fashion, using the natural shape of the brush shoulder, define the masses and coloration of the fish. Neutral gray detail completes the final accents, again applied sparingly.

MATERIALS

Silk Paper

Watercolor Paper

Chinese Goat Hair Brush

Colored Inks

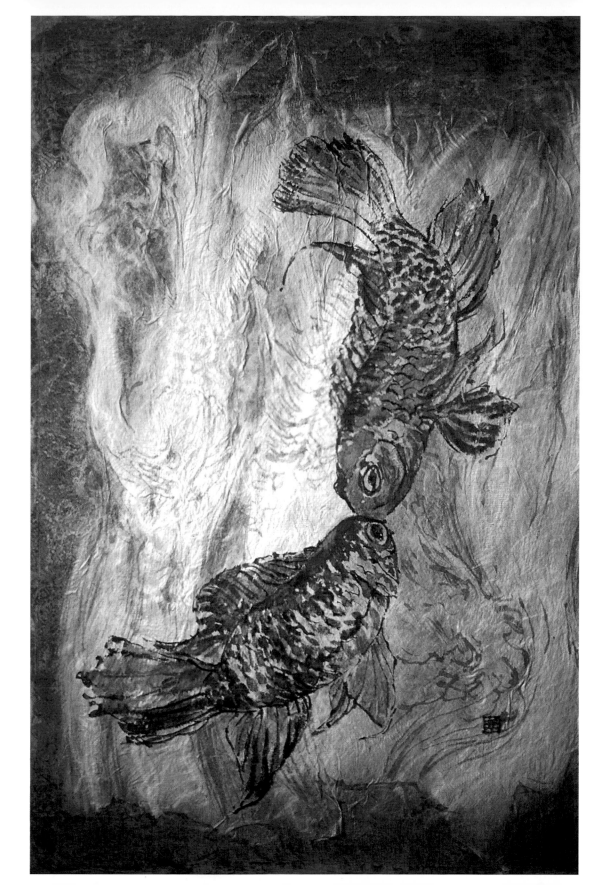

Introduction

By now you have worked with line enough to begin to understand what it has to offer and are aware of how it can be manipulated to serve your purposes.

Moving a brush or pen at different speeds across the surface allows differing amounts of paint or ink to be deposited. A slow movement creates strong dense line, while moving fast results in a thin or scuffed line. What can these two qualities do for your subject?

Imagine which you would use for a butterfly's wings and which for a solid piece of log or rusted iron.
Could the speed of line application be varied along a single silhouette? When drawing a human head, what difference could be made between flesh and hair, what of highlights and shadows?

Along with speed, goes pressure. Pressing hard on a brush or pen increases the lines density. Thus, pressing hard and moving slowly will be exactly the opposite of a gentle fast line, with all the gradation between the two.

Pressing hard on a brush also tends to open up the filaments or hairs. With a pen the pressure will cause the pen to falter as it comes into greater contact with the fibers of the paper. All of these qualities are often created instinctively, rather than through conscious reaction; but all will play their part in creating a unique line quality. The more aware you are of these, the sharper your instincts will become and your reaction to them.

So much for the manipulation of the line by the artist. Now let us look at the changes created by the drawing tool itself. A point can be thick, thin, chisel shaped, italic, rounded, blunt, flat, wide, soft, or hard — all of which have a profound effect and all of which give the artist more choice.

Simply loading a brush or pen differently can make serious differences in application. A poorly loaded brush will scuff, especially on a textured surface as opposed to a smooth one. Heavily loaded, the ink or paint will solidly fill the surface or even spread along the paper's fibers, producing blurred or smeared effects.

Once you really begin to work at it, line becomes one of your greatest assets. From being something that is found arbitrarily along the edge of a silhouette, it takes on a much more serious role. By careful manipulation, it can describe or suggest so much about the object it surrounds. Once you are aware of these possibilities, you will begin to use them, eventually on a subconscious level, and your drawings will gain infinite subtleties and strength from their presence.

MATERIALS

Pencil

Pastel Pencils

Waterproof Drawing Ink

Colored Inks

Dip Pen with One Drawing
Pen point

Watercolor Paints

Oil Paints

Brush Pen

Small & Large Round
Bristle Brush

Rigger Brush

Round Watercolor Brush

Kneadable Putty Eraser

Compressed Paper Wiper

Watercolor Paper

Textured Pastel Paper

Canvas Board

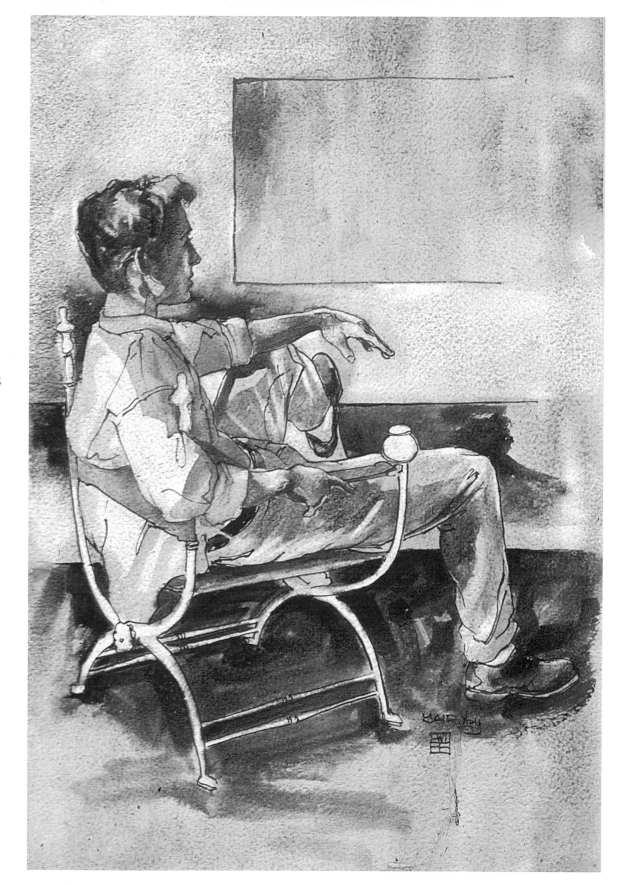

Pastel Pencils

By using just these two colors you will be following in a well-established tradition. The lighter sanguine is used for the "washes" or shading, applied rapidly by using the edge of the pencil. Note how it picks up the texture of the pastel paper. For this sketch, the reverse of the sheet was used, as the front was too regular for my taste. The color can also be pushed and smeared across the surface into some of the texture. Make as much as you can from this first color to distinguish the subject, but hold back from linework.

The linework is now applied throughout, using only the darker sepia pastel pencil, and exploiting as many qualities of line as possible. Little "internal" line is used inside the subjects. Note how much can be described simply by augmenting their silhouettes, where these appear or disappear; where they appear thin, thick, broken, solid, soft, or hard to make the statement.

F E D C B A

[A] Select pastel paper with a "grain" to suit your style and subject, for its texture will be picked out by the pastel.

[B] Lightly sketch out shapes in first "wash" of color — Sanguine. Then, use side of pencil point for soft shading.

[C] Push and smear the Sanguine across and into the surface texture using a compressed paper wiper. Hold back from adding more linework in this color.

[D] Use a kneadable putty eraser to re-establish highlights as well as correct.

[E] Sepia pastel pencil line applied mainly to the silhouettes.

[F] Note differences of line quality, all achieved with the one pencil.

Dip Pen, Ink, & Watercolors

As you are using permanent waterproof ink, you will find that an accurate pencil outline is helpful before you begin. However, fluidity of line is more important than accuracy, so to some degree the amount of pre-drawing will depend on the complexity of the subject. This particular study may at first seem a little complex; nevertheless, it was completed using only one pen point size. Various sizes are available, and you can change constantly throughout your drawing. The purpose of this exercise, however, is to demonstrate just how flexible one pen point can be. A drawing pen point with a point is essential, rather than an italic pen point. The former yields some variation of line thickness, controlled by pressure, while the latter by direction of stroke. The line strength is varied in two other ways. You can revisit a line to make

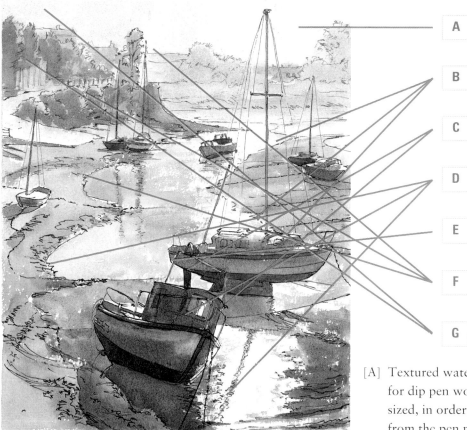

A

B

C

D

E

F

G

it bolder, or add water to the ink. In this sketch, the foreground was drawn first, using full strength ink, and water was then added progressively into the distance. Working from the front to the back ensures solidity of overlapping shapes. As the ink is watered down, test on a scrap piece of paper. You will find that Indian ink is particularly strong and requires much dilution.

Overlaid watercolor washes must respond to the ink strength. Note how even in the darkest areas of shadow the line is still dominant. This ensures great freedom with the watercolor, as detail is carried by the line.

[A] Textured watercolor paper is suitable for dip pen work, providing it is well sized, in order to withstand scratching from the pen point and yield a fluid line result.

[B] All these lines are completed using only one pen point size.

[C] Overwork lines to make them stronger, fatter, and denser.

[D] Foreground lines are drawn first in full strength.

[E] Working from front ensures overlapping shapes are solid.

[F] Progressively diluting ink line into distance creates sense of depth.

[G] Simple color washes add solidity and mood, but do not compete with linework.

Oils

While oil paint is usually thought of as being a heavy textured medium, when thinned down it can be used effectively for linework. Here the thinner used in the mix is a homemade "oily thinner," comprising of a 50:50 mix of oil (Purified Linseed Oil) and thinner (Artist's Distilled Turpentine). This creates a fluid, slow drying mix with the paint.

Draw out the shapes with a round bristle brush and a fluid mix of the paint, so as not to get too detailed too early on. Block on solid areas of color with the same fluid mixes, adding white for opacity where necessary. While still wet, dab off color with a crumpled tissue (tonking) to create texture. Finish off with linework, using a Rigger brush and a stiffer mix of blue, brown or green paint.

It is essential you work on a non-absorbent surface. Use a prepared canvas board, suitable for oil painting, or prepare your own by painting a piece of smooth, sanded hardboard with emulsion or acrylic paint.

Use small round bristle brush to draw basic shapes. Avoid detail and worrying over linework.

Use large bristle brush to block in fluid washes of solid color.

Tonk still-wet surface with crumpled piece of craft tissue paper.

Develop descriptive linework with Rigger brush.

Inks

Painting is not just about capturing exactly what is in front of you; it is about what you want to see or what you imagine you see, or would like to see. A "fantasy landscape" created in a terrarium is itself translated into a "fantasy" landscape painting. The composition was treated as a view seen through the "window" that is the front glazed panel of the terrarium.

Several important decisions have to be made before you begin such a subject. What are the important aspects of the composition? As there was a preponderance of green, I decided to concentrate on the diverse structures and linear qualities evident everywhere in this "fantasy jungle." What media will you use? Personally, I felt that colored drawing inks would best suit my need for linework to create structure, while harnessing their luminescent qualities to enhance the feeling of fantasy.

Work out your composition in a sketchbook before you commit yourself to the watercolor paper. Translate your sketch onto a stretched sheet of 140lb Hot Pressed (the smooth surface is ideal for linework and inks), using a 2mm 2B pencil, drawing in broadly but as gently as possible to enable you to make corrections should you need to. It is also important to keep as much of the surface clean and white so that the inks will remain bright.

MATERIALS

Pencil

Brush Pen

Rigger Brush

Round Watercolor Brush

Kneadable Putty Eraser

Watercolor Paper

Waterproof Drawing Ink

Colored Inks

INKING IN

Ink line is better started at the front of the composition (bottom of the paper) and worked back into the distance (upward on the paper). The simple reason for this is that ink line once applied cannot be erased. Therefore, when overlapping forms it is sensible to first draw the nearest so that those behind can be drawn only up to the edge of those in front. I used a brush pen in the foreground to not only deliver a very solid black line, but its flexibility also enabled me to create linework which expresses forms, even when used solely as the silhouette. The foreground stones, for example, have a thicker line along their bottom edge, suggesting shadow. Try to keep to this silhouette without using the line for shading. Instead, concentrate on the rhythms and variations in the line around the edges. By the time I had worked back to the pitcher plants, I felt a more gentle line was required to suggest depth. To do this you will need to water down some black waterproof drawing ink. Ensure it is waterproof and lightfast, as you don't want subsequently overlaid layers to disturb your careful drawing. A simple tip, but a problem that crops up time and again.

Use a No. 3 Rigger to apply the line, even around the window edge. Apply this freehand, no matter how tempted you are to use a ruler and pen. Artificial lines produced in this way would stand proud of the drawing and prove unsympathetic to the line qualities elsewhere. Keep stirring the ink solution, as it does settle and consequently your brush marks will become lighter. Do, however, water the ink down once more for the most distant backdrop of ferns, to again suggest depth in the composition.

TIP

When watering down ink, you will find that the black especially is incredibly powerful and will take a lot of liquid before it thins to your requirement. Often, however, the solution looks darker than it actually is, simply because of the depth of the well it is in. To test this, paint out a thin wash, keeping your brush on the paper surface to ensure an even layer. Then allow to dry. Only now can you determine whether the intensity of the ink wash is correct. This prevents you making mistakes on your actual work, mistakes which would prove impossible to rectify once in place. Carry out this test on the colored inks as well to prevent possible loss of intensity and/or value once dry.

BLOCKING IN COLOR

Once the ink is fully dry, clean up the paper with a putty eraser, leaving only the ink line on the surface. As you continue to now block in the first colors, you must take into account the difference between paint and ink. Paint color is usually a pigment, which lies mainly on the surface and can thus be easily removed. Ink is a dye or stain which rapidly penetrates the fibers of the paper and is thus much more difficult, if not impossible, to remove. Often you will discover that if you do try and lift ink after it has dried, you will only remove a part of the mix. In other words, when you lift watercolor, the color becomes lighter; but when you try to lift ink, the colors may change. The part of the color that is less easily dissolved remains as a stain in the paper fibers. This quality is much less easy to control, but was to prove a major factor in the production of this painting. A side effect of fast drying is hard edges. Often it is sensible to prewet a surface before you apply ink, if you know beforehand that you are going to soften (lose) an edge. Work in small areas for the best control (restricted wet-on-wet). Masking fluid is most effective with inks and can be used for highlights or textures as with watercolors. Greens are kept very yellow to best suggest sunlight. They are interspersed with the warmer colors of the Venus flytrap, the driftwood, the window edging (leading), etc. which help — by contrast — to keep the greens intense.

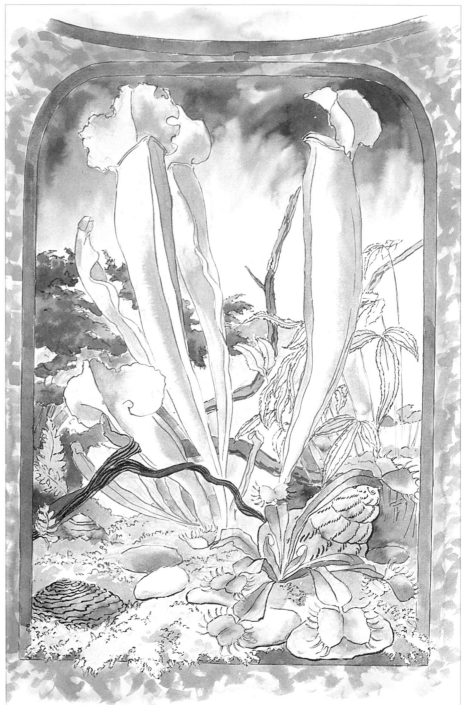

ACCENTS & COMPLEMENTARIES

At this stage you need to add darker colors against which the lighter colors might shine. Ink colors are difficult to mix to a dark tone, due to their natural transparency. The reds, blues, and purples, which begin to appear behind the pitcher plant, are color mixes. Being generally complementary in nature to the green, I had hoped that they would offer real contrasts to the light green. However, they began to look too bright themselves due to their transparency. To counterbalance this, I added black ink into the green mix used for accents on the "grass," and I felt this was closer to my requirements. The dark green that surrounds the "window frame" also begins to look too intense, without the addition of black. While being generally content with the composition at this stage, I was very unhappy with

the color balance. Something was needed to restore some softness and mystery to the "fantasy" mood. This was one of those moments. I paced the studio. I had a coffee and sat looking and thinking of all the different possibilities and what they would do to the picture. Eventually, I decided on a drastic course of action. The color overall needed to be taken down so I would see how much color could be removed! Then I would introduce some grays in which I could employ more of the black ink. Finally, I would soften some of those hard edges. The decision made, I went to the sink!!!!!!

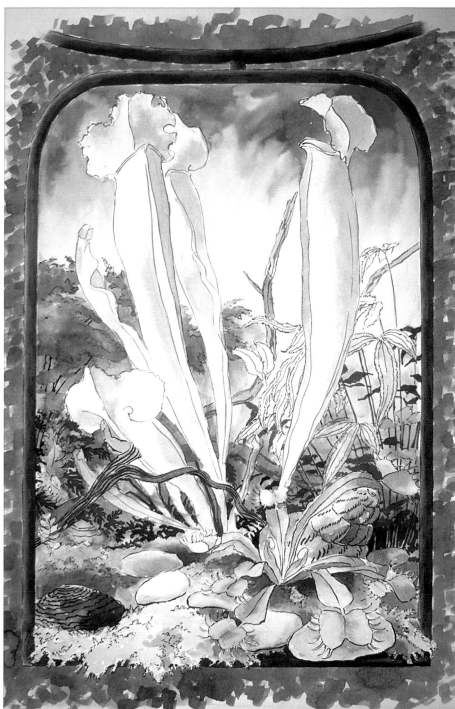

Saving a Painting That is Not Going According to Plan

To follow this course of action you need to be bold. You can either "wash" the painting under a running tap or immerse the whole in a tub of cold water. As this is waterproof ink, you can be very vigorous in your removal of color. I actually used a nailbrush in areas, especially around the window borders, and you can see the dramatic effect on the colors. (Don't be so vigorous as to damage the paper!) Once satisfied, you can speed up drying with a hair drier. As I was now keen to use some masking fluid, I did of course have to ensure the surface was bone dry.

To Continue

Apply masking fluid over all the central details you wish to preserve. Unlike situations in which you are applying a mask over watercolor, the fluid will not remove ink color, especially the pre-washed layer. Now I mixed a dark wash of blue-green plus black ink, and having first wet the whole central section, applied it wet-on-wet. You can see how I follow the structures of the background, but now they become duller, darker, and softer. Highlights on the grass (sphagnum moss), stones, and flower traps were masked, and when dry, a yellow-green plus black mix was applied — again, wet on wet. When all your inking is dry, remove the masking fluid. At this point you need to decide on whether more linework is required (cross-hatching etc.). In this instance, with the freshness of the green now against the soft dark background, I decided it would be inappropriate. Often a painting is completed with the decision as to what not to paint. After a traumatic time in the middle of my painting, I was now certainly satisfied with the result.

As with anything, we learn so much more from being faced with problems and having to sort them out and what a satisfying feeling when the end result justifies the means by which we got there!

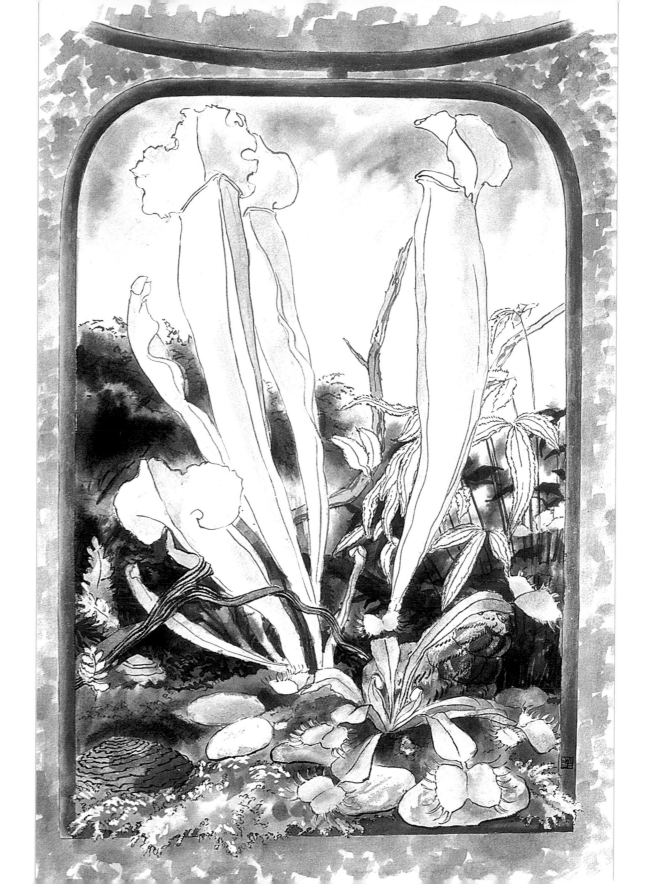

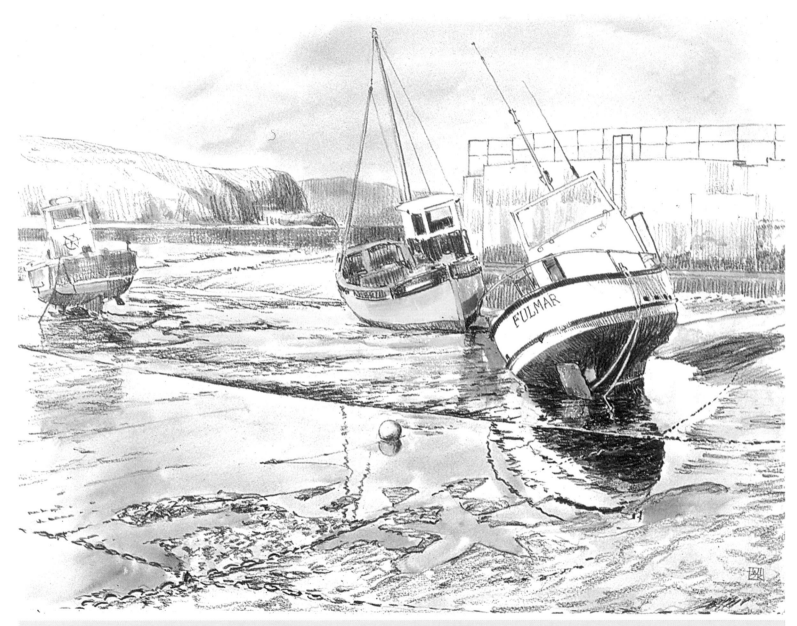

MATERIALS
Watercolor Pencils • Pencils (HB & 2B) • Charcoal Pencils • Oil Pastel (1 color) • Watercolor Paints • Round Watercolor Brush
Flat Watercolor Brush • Colored Pastel Paper • Oil Paints • Canvas Board • Kneadable Putty Eraser • Linseed Oil
Artist's Distilled Turpentine/Odourless Thinner • Compressed Paper Wiper • Erasing Knife

Introduction

As soon as several lines are laid next to one another, their apparent strength increases. Our eye is drawn in their direction, which seems to suggest movement across the surface, as our brain links the individual lines into a common surface.

The length of these lines creates different effects. Longer lines suggest the elongated movement of smooth speed, while short lines evoke more staccato movements or rippled effects.

In traditional Indian miniature painting, which employs a lot of linework, the first lines are made around the silhouette outline of objects. Lines that go inside are said to "cut" the subject. This cutting suggests internal surfaces or planes. If the lines are straight, the plane is flat; if curved, the plane then has a curved surface.

In Western painting this is referred to as line "hatching." I have always found it fascinating that the word hatching is so close to thatching, for in both a surface is being created by bundling together lines, or in the case of thatching, linear objects. Adding color to these lines can result in several effects.

If the color is transparent, the power of the linework shows through undiminished. The color remains pure and unsullied by the linework. It can even seem intensified by its proximity to the line, especially if the latter is particularly dark in value, such as charcoal.

When the color is made semi-opaque and painted across the lines, they are then reduced or softened. This is useful where structure is essential, yet color needs to predominate.

Fluid color can begin to dissolve the linework, but as long as it does not completely disintegrate, a partially dissolved line can impart unique qualities. Partial removal of the line, using an eraser, can also fade a line in a gradual and carefully controlled way, allowing applied color to be either transparent or opaque.

We can also explore the possibilities of directional line and wash being applied to perspective. If you haven't already used perspective, don't let this put you off, for you may be missing out on a whole range of possible subject matters as a result. For the painter it is nothing like technical drawing with which it is so often associated.

From this simple introduction you can see that directional line can be mechanical and precise, or loose and free. Whatever your mood or your approach, there will be a range of line techniques to suit your taste. Experiment away and enjoy the possibilities ahead.

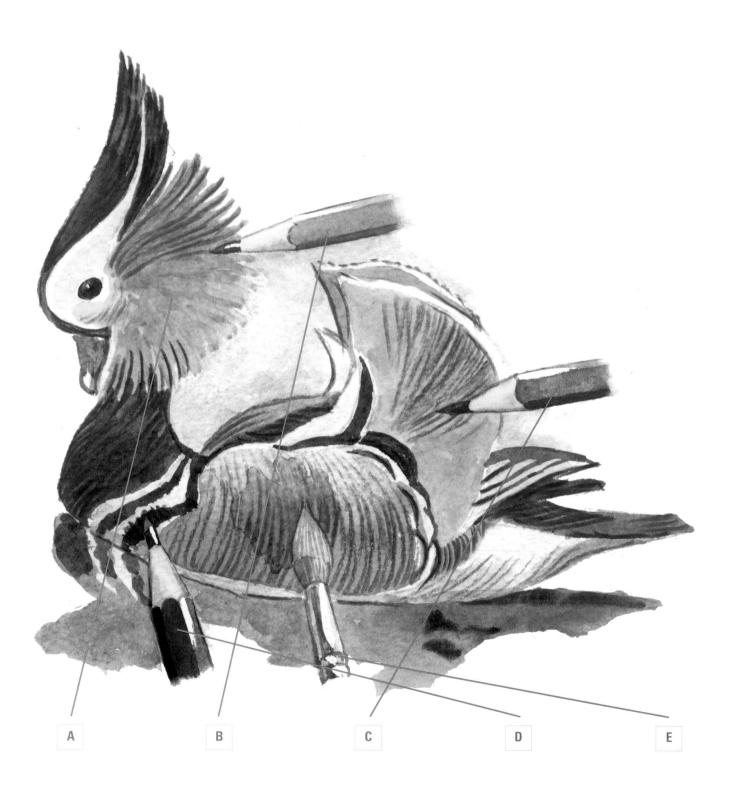

A

B

C

D

E

Watercolor Pencil

The most obvious place to start with colored line is
with a colored pencil. Use a watercolor pencil and
you have the option to turn the line, or at least some
of the line, into a wash of the same color. Don't
think of watercolor pencils as a substitute for
watercolor paints; look upon them as a medium in
their own right and exploit their unique qualities.
Whereas the strength of watercolor is in the fluidity
and translucency of its washes, watercolor pencils
have the added dimension of texture. To completely
dissolve the line into a wash obliterates this texture,
do so judiciously.

[A] Watercolor pencil can be completely dissolved
 into a wash.
[B] If the pencil lines have been dissolved completely,
 they can be reintroduced with further pencil,
 either applied wet or dry.
[C] The curve of the line gives it direction and
 suggests the form of the feathers.
[D] Color mixing can occur on the surface. Here
 brown is laid over blue to give a dense colored
 gray.
[E] To preserve the directional structure of the line,
 which here suggests the roundness of the body,
 brush the water in the direction of the line flow
 so that the line is softened but not eradicated.

Gently dissolving the color so that it fills in the white paper between the lines
makes the color more powerful and the objects more solid. But try to retain the
pencil lines themselves so that there can be no doubt in the finished piece that
you have exploited the watercolor pencil to its full extent.

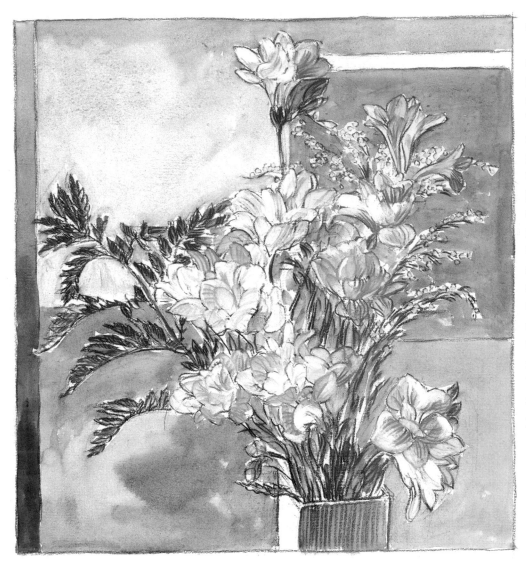

Charcoal Pencil & Watercolors

Charcoal pencils create wonderfully dense linework. Here it is contrasted against both transparent and opaque watercolor washes. When used transparently, the watercolor is modified by the color of the underlying pastel paper. After adding white however, the coverage is more powerful over the paper and the linework alike. This has an advantageous softening effect over the petals.

Color must be stroked unhesitatingly in the same direction as the charcoal linework, so as to cause the minimum disturbance. Clean the brush frequently to remove any charcoal that may have adhered to the brushhead, as this will eventually soil colors if not removed.

While the charcoal could be fixed, the gum in the paint will itself fix the charcoal powder, so the choice is yours.

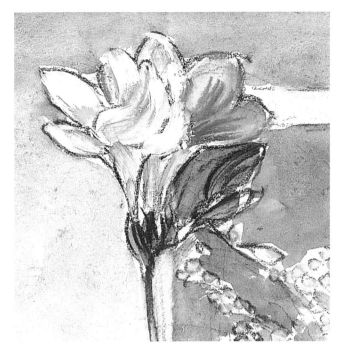

Stretch pastel paper. Loosely sketch composition with charcoal pencil.

Apply heavier pressure & develop the study with directional linework. Keep pencil sharpened using knife.

Pull color along petals with unhesitating strokes. NOTE - slightest overworking will lift charcoal!

Use Titanium White in the mix to make watercolors opaque - excellent for covering color of paper.

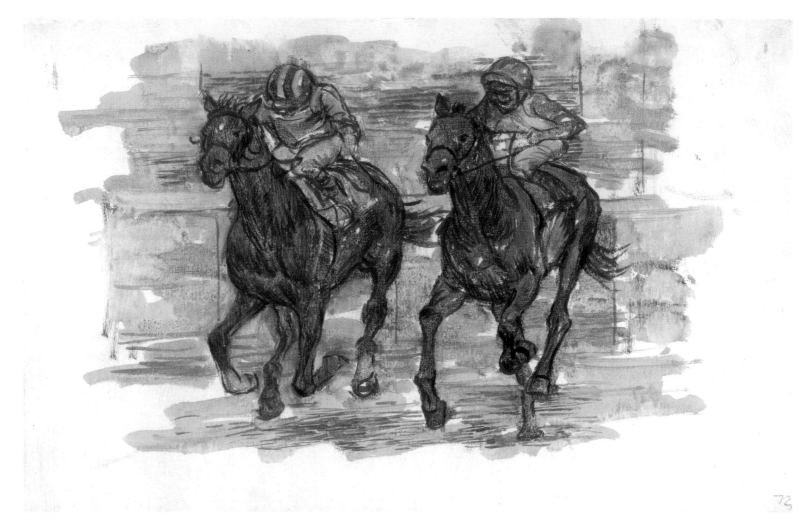

72

Oils

This oil sketch shows how directional line, hatched across the horses, can express form, while the horizontal hatching used for the background is expressive of movement and speed. Underlying color is thin here, being diluted with oil thinner. Several tonks are employed by dabbing the surface with newspaper, which is kept smooth rather than being crumpled. The texture is developed by the squashing of the fluid oil surface.

Note how that the directional line changes color, depending on the surface over which it is hatched, and this weaves itself into the structure of the painting. Linework can be also tonked, especially when very fluid with added thinner, by using just the end of your finger.

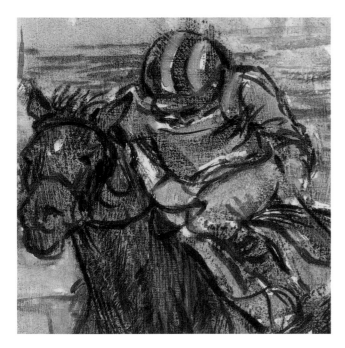

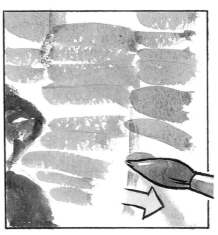

Establish large directional strokes using a large nylon brush and fluid paint.

Tonk still-wet surface with a smooth sheet of newspaper.

Over heavy areas? Apply extra oily thinner (top) directly to the surface and tonk again (bottom).

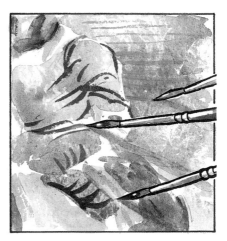

Simple loose directional line applied with small round nylon brush suggests movement — emphasizes volume.

A R T S T R I P S

73

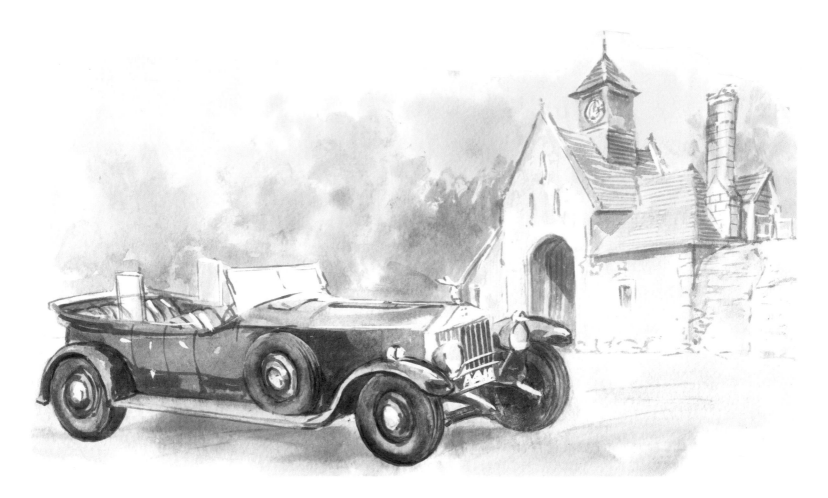

Perspective & Directional Line

Buildings and objects such as cars are constructed from some important directional lines, those of perspective. The very word can strike fear in even the most stalwart souls of those who have not studied the technique.

However, perspective should be seen as a friend. It is simply a method of suggesting that our picture surface has depth. As we know that it does not, the inclusion of perspective is a useful tool to create the illusion.

Since it is an illusion, all that matters is that it works, and there is no need to fear the rules that seem to govern it.

Rather than rules that need to be obeyed, see these as guidelines, and there is one true guideline above all others and it is this: if the picture looks right, then it is right.

This study demonstrates a simple insight into how perspective can confuse or help you.

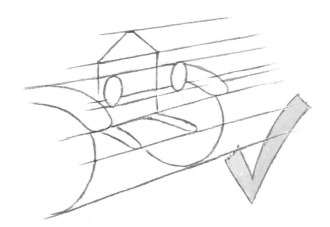

You could create a grid of directional lines that converge slowly on one another and then fit the details of the car on top. The most important point here being that lines of perspective do not cross within the drawing. In fact, they meet at a vanishing point, but this can be confusing as it is often well outside the drawing and even off the page.

Even more alarming, there are often two or more vanishing points to confuse the issue. So how do we judge these angles?

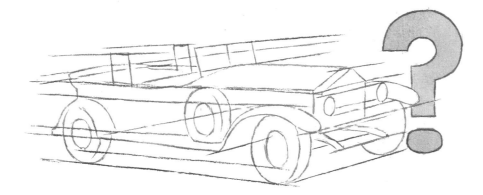

The answer is not to worry about where the lines are going to. Instead, gauge their angle by holding your pencil horizontal against one end of the line in question. The angle between the pencil and the line is then easy to judge and place on the surface.

Oil Pastels

For this study use one color only. This is a useful exercise in understanding the medium and to exploit the possibilities for texture and tone. Since the pastel is to be dissolved and spread with thinner (either Artists' Distilled Turpentine or Odorless Thinner), it is essential to have a suitable ground on which to work. Canvas board provides both the strength and a prepared surface, which can take the turpentine washes without sustaining damage.

STEP 1 - DRY
Don't work too small, as the canvas texture can easily overwhelm fine detail. Correction to the initial dry drawing can be erased fully or partially with a kneadable putty eraser.

ARTSTRIPS

STEP 1: DRY

Pastel strokes break up on canvas texture. Don't be tempted to increase pressure and fill in.

To correct heavy application, dissolve with turpentine [top] and dab off with absorbent tissue [bottom].

Different parts of pastel, differing pressure and direction of stroke offer abundant possibilities.

Begin to suggest form by using directional strokes.

STEP 2: WET

Thinner dissolves oil in pastel, allowing washes of pigment to invade deep textures of the surface [magnified above].

First washes of turpentine soften and smear applied pastel and fill in white gaps.

To solidify and balance lights and darks across composition, apply more turpentine to selected areas.

Wipe brush frequently to avoid color being carried too far. You are dissolving with brush, not painting.

STEP 3: DRY

Accents and linework applied with pressure provide sharp detail and focus.

Use both point and shoulder of paper wiper to push and smear strokes into and over surface.

Remove over-enthusiastic application of pastel with erasing knife.

Some accents improve by being softened gently with turpentine applied with a round brush.

STEP 2 - WET

Work flat to avoid runs as you dissolve the oil pastel with washes of thinner. Now you can see how much pigment is already on the surface, and a second series of washes develops the density of the color even more without any additional oil pastel. The image becomes soft and unfocused, a perfect foil for the next layer of pastel strokes. This very softness suggests a painted, rather than a drawn, surface. Oil painters could well use these two stages as the first step to a full oil painting, but here we continue with pastel alone.

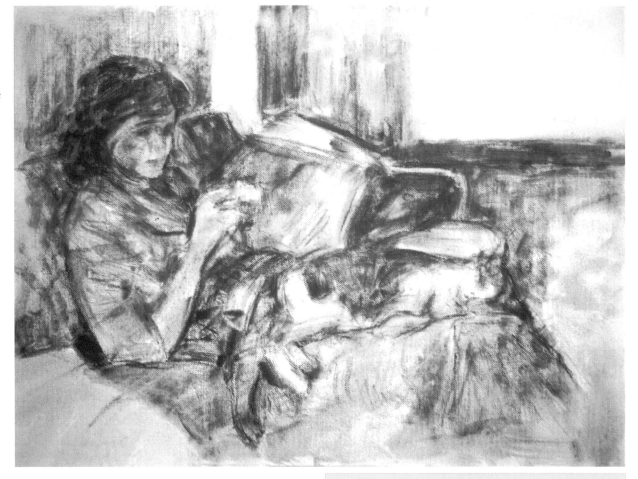

MATERIALS

One Color of Oil Pastel

Artist's Distilled Turpentine or Odorless Thinner

Canvas Board

Kneadable Putty Eraser

Round Watercolor Brush

Flat Watercolor Brush

Compressed Paper Wiper

Erasing Knife

STEP 3 - DRY

Dry pastel strokes now provide rhythm, pattern, accent, texture, and line. The image solidifies with its application, and some dry blending is achieved with a paper wiper. Crude linework or solid areas are relieved by scraping off with a craft or erasing knife. Exploit the canvas texture with hatched shading (hair, walls, etc.). Some areas becoming over-dark are re-wetted with a soft round brush and dabbed with a tissue. The area behind the head shows this unique texture to good effect.

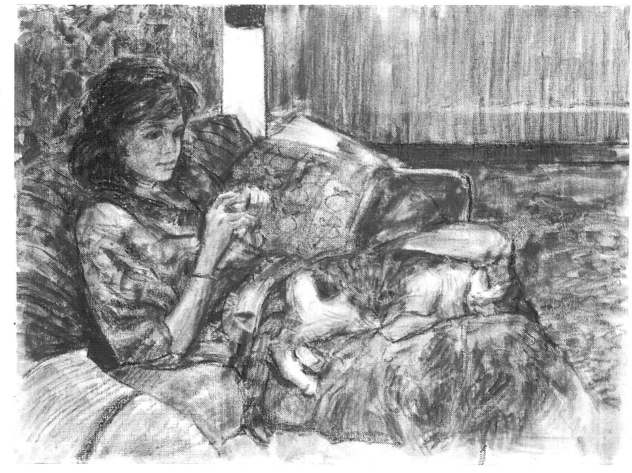

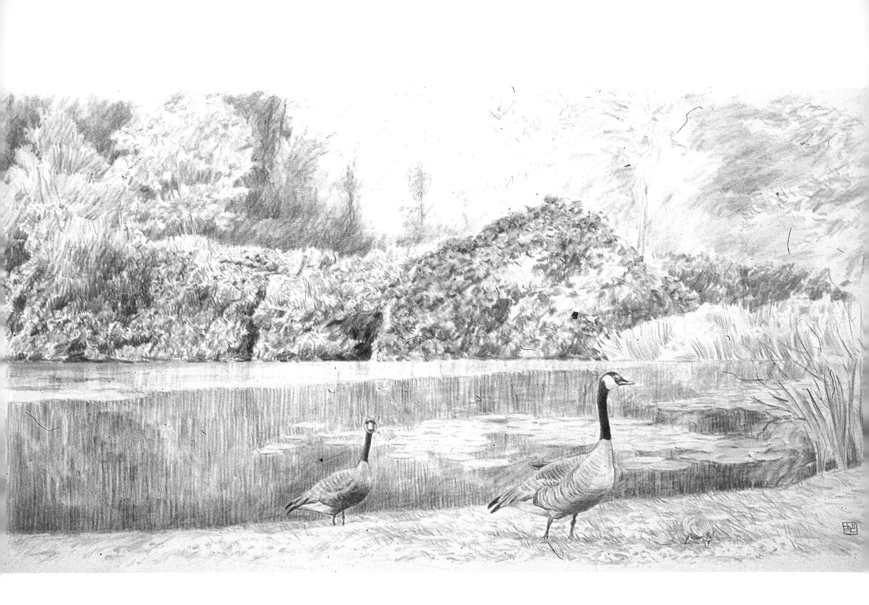

MATERIALS

HB & 2B Pencils • Watercolor Pencils • Sketching Pastels

Rigger Brush • Round Watercolor Brush • Waterproof Drawing Ink

Colored Inks • Watercolor Paints • Kneadable Putty Eraser

Watercolor Paper • Colored Pastel Paper • Sketchbook With Watercolor Paper

Gum Arabic

LINE OR COLOR?

Introduction

What color is a line? When does a line become a stroke? Where is the line crossed between drawing and painting?

Interesting questions, but of course none of them actually require an answer. The fact is, they all suggest choices and possibilities. It helps occasionally to stop and think about the techniques you are using, for in analyzing them you can often come up with alternative approaches, which is how to make progress.

First find a direction that fits your temperament and ambitions and move along the path at a pace to suit you. Don't worry if the first techniques are basic and seem a little simple; it is by starting in this way that you become filled with confidence. As your skills improve, you will begin to demand new challenges, and what may have begun quite simply, can end up as a well admired and cherished ability.

So it is with the use of line. Now that we move into color, we can start to look at a variety of media that can offer us this option. What was begun as pencil has now entered the realms of paint.

The few options that are suggested in this chapter are only just the beginning of your journey. With color comes all the inherent possibilities: aerial perspective, color harmonies, colored grays, changes of mood, balance of color — the list is endless.

You can dip into pastel, oil, gouache, ink, watercolor, and more. In each case you will need to assess the particular qualities each medium projects on the line it makes and then exploit its nature. Once you understand the qualities involved, linking them to a subject will come naturally.

Would the soft fur of a rabbit be best rendered in pen and ink or in charcoal? Would making the less obvious choice offer more of a challenge and produce something unexpected?

By the time you have reached this point you need no longer worry about the barrier between painting and drawing, for it has already been crossed. The linework with which you began can now become a sensitive brushstroke, which can take on the role of being a scribble or a sketch, a descriptive or directional line and finally, of course, be rendered in full color.

You will also have gained confidence in painting washes behind the line. With these

you are dealing with broad coverage and texture, rather than detail.

Already you have experienced the pleasure of applying soft, unfocussed color and will have developed confidence and speed in its application.

Although you are nearing the end of this book, you are actually approaching the gateway to a whole world of possibilities. There are so many routes for you to take and you will inevitably choose one that is unique and reflects your individuality.

LINE

Dissolved Heavy Line/Stroke

Lines or strokes of color created in pastel are best seen against a colored ground, and this study is completed on a tinted pastel paper. These are sketching pastels, the semi-hard variety, which come in at a very reasonable price. The hatching of the lines that provide all of the color successfully mixes the color visually on the surface. Being pastel, the lines must be bold, but this imparts a rigid dynamic quality to the drawing. Blending these colored lines with a gum Arabic solution not only spreads the pigment but also, when dry, fixes it to the surface. Application of the fluid (50:50 gum Arabic to water mix) should be made in the direction of the line itself so that it will not be completely obliterated. Use a soft brush to do this.

As the paper is a dominant color, white can be used as a color in the finishing touches. This should be left unfixed to keep it "sparkling".

Draw outlines in dull orange (top); add color loosely. Do not cover paper entirely; allow color to show through.

Blend strokes into washes with solution of gum Arabic. Follow direction of line and clean brush frequently to prevent muddy colors occurring.

Strengthen silhouettes with colored line.

White hatched highlights left unblended allow undercolor to show through (visual mixing).

83

LINE
Neutral Line

These two studies demonstrate the choice available between, on the one hand, using line in it's own right, against using it as color.

First, we take the traditional approach of a dark ink line, supported by washes of colored ink. The line is applied with a Rigger brush, bringing some life to an otherwise flat and static subject.

Once the linework is dry, apply ink washes. Simple ink washes show ink at its most luminous, but there are two differences between using ink and watercolor for your washes and linework. Ink dries much more swiftly than watercolor and once dry, is fixed. This is due to the fact that the ink is a stain, which quickly penetrates the fibers of the paper. Watercolor is traditionally created from pigments that lie on, or much nearer, to the surface of the paper.

Once you acclimatize yourself to these differences, ink offers a little extra variety, and its permanence afford successful color layering, without fear of unwanted color lift.

Pre wet a nylon Rigger brush and load with neutral gray drawing ink.

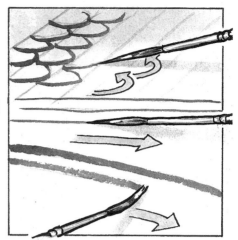

Ink application can be swift and sensitive with looped, pulled, drawn, swept, and dragged linework.

As ink dries quickly, pre wet paper to avoid permanent hard edges on ink washes.

A piece of wax candle rubbed over first dry colored wash will resist next wash in selected areas.

LINE

Masked/Colored Line

Now the line becomes color. Using the same Rigger brush, draw in the linework, but substitute ink with masking fluid. This is a large area of masked line, so be careful your brush does not become solid with the drying fluid. Stop as soon as you experience a slight drag on the brush, and clean the brush thoroughly, ensuring that no masking fluid remains. Add a little more soap to the brush and recommence the linework where you left off.

Once completed, allow the masked linework to dry thoroughly before applying the ink washes. For this study, however, the background is painted in neutral gray ink, applied wet-on-wet to achieve the soft edges around the perimeter of the vignette.

Once the ink washes have dried, remove the dried mask, which will expose the linework as the white of the paper's surface.

Now apply colored ink, working wet-on-dry, into the clean linework.

Note how not all of the linework is filled in with color. Leaving touches of white allows the white to work as a color in its own right and suggests highlights.

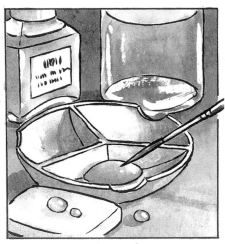

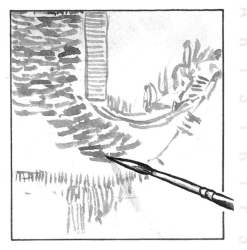

Pre wet a Rigger brush and add a touch of soap to protect it. Load with tinted masking fluid.

Be generous with linework, as it looks stronger against white than it will do later against color.

Wet surface and stroke on successive layers of ever-stronger neutral gray ink.

Once dry, remove mask (top) using kneadable putty eraser. Apply color (bottom) using simple mixes of only three colors.

Watercolor Pencils

Every year, when the Wisteria bloomed in the garden of our previous home, I was reminded of Monet and his garden. Of the wonderful paintings created by this magnificent artist, inspired by his now famous bridge, draped with summer blooms. Every year I promised myself that I too would be inspired to set up my easel, take out my brushes and palette, and commit the liquid cascades of purple tinged racemes that are the hallmark of this glorious plant. Finally, I could put off no longer the lure of an ever-burgeoning growth and decided that come what may, I would commit a detailed study to paper. Thank goodness I did, for now we have moved to the Highlands of Scotland, this is an ever-present reminder of the plant that we had carefully cultivated and nurtured.

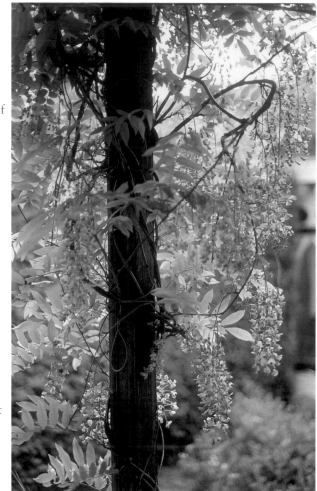

BEING PREPARED

A case such as this brings it home that being prepared pays dividends. Luckily, this was my back garden; hence the choice of materials was limitless. What did not differ from being out and about, however, was the lack of time I was able to commit to the study and this influenced my decision. It is always as well to have a basic kit of materials that you can turn to for these snatched studies; one that can be used quickly and efficiently, and which can also be discreetly tucked into a pocket or small bag.

Never Put Off Until Tomorrow, What You Can Do Today!
How many times do you say to yourself, "if only…" That could so easily have happened to me on this occasion. I started the study late in the afternoon and continued until the sun was beginning to set, and the color and structures were beginning to fade into the gloom. As can be seen from the reference photograph, this was a study that had to be done on the spot. The photo was unable to capture the depth of the stem structure against the over dominant pillar around which it clings. The next few days brought lashing rain, and every bloom of the Wisteria came fluttering down to Earth. I had been in the nick of time.

The Basis For More Paintings?
Sketchbook reference gathering provides artists with a goldmine of inspiration. Coupled with photographs taken at the same time, I may well yet produce a dramatic oil painting. The irregular shapes and busy nature of the plant would provide a lively subject for the short, brush-like marks that can be achieved with soft pastels. Or there again, the romance and sensuous nature of the drooping foliage and blooms would be well described with the qualities inherent in the Wet-on-Wet technique of watercolor painting.

MATERIALS

Sketchbook
(Spiral Bound)

Selection of Artists quality Water Soluble Pencils (13 in total)

Kneadable Putty Eraser

No. 6 Round Brush (Nylon/Sable mix or Sable)

Absorbent Paper Towels

SKETCHING IN - COLORS :

[1] ULTRAMARINE LIGHT [2] DEEP COBALT

Scribble in the initial sketch with [1] — this will both recede against colors to follow and also be compatible with the color of the flower. Keep the drawing loose to balance the delicate blooms against the rhythmic structure of the interweaving branches, while playing down the heaviness of the central pillar. The pencil lines at this point are easily erased with a putty eraser, so this allows for freedom of movement - easily wrought changes were necessary here. The central pillar, which I certainly did not want in the middle, was moved several times to the right until I felt that its positioning was correct. The drawing at this stage can be very selective. Don't feel that every leaf has to be committed to your study. As you feel your way around, discovering the shapes, choose those that help the composition and reject those that do not. This is the point where your personality starts to become imprinted on the work. Once the balance of the masses has been satisfactorily achieved, tighten up with the darker color [2]. The drawing at this stage should be carried out with only gentle pressure and the point of the pencil.

SHADING - COLORS : [3] LIGHT MAGENTA [4] ZINC YELLOW [5] LEAF GREEN [6] TRUE GREEN [7] APPLE GREEN [8] GOLD OCHRE

The real enjoyment in colored pencils is to give yourself plenty of choice so that you don't need to mix your colors, but can get as close as possible with the pencil you choose. Sharpening [3] to a long point, use the lead "shoulder" to gently shade or "block in" the masses. Don't use too much pressure at this point, or the lead could snap and/or you could apply too much pigment. Observing that the color intensified toward the base of the flower, I did allow more pressure for a denser application. Generally, however, the colors should remain light so that the darker values of leaf and stem around them will provide the contrast they require to stand out. Now you can interweave the background around these shapes, without obliterating them. Begin with the leaves. I had decided not to overplay sunlight, as too much yellow — being a complementary color — would dull my purple flowers. However, the green can still move from warm to cool colors [4 : 5 : 6] These gentle colors are worked almost to the edge of the page. As the drawing progresses, the overlay of colors can become more centralized to create the focus. Strengthen the upright post slightly, with [7], whereas the stems could be given the warmer [8].

WETTING - NO. 6 ROUND BRUSH

Wet each color in turn so that color won't
run, almost tickling the surface with the top
half of the brush head. This process is not
like watercolor painting, as one has to slow
the speed of working in order that the
pigment can soften and flow. Too slow and
you will find the colors become too soft,
losing any indication of former linework.
Practice on scrap paper until you get the feel
of the medium. Colors spread and those that
are overlaid mix on the paper. Pools of
color dry with a hard focused edge, as in
watercolor. The blue "structure" lines are
lost by working them into the background
so that the whole study starts to become
softer and more painterly. Keep a piece of
absorbent paper towels to hand, so that you
can blot off any colors that run or begin to
mix unpleasantly.

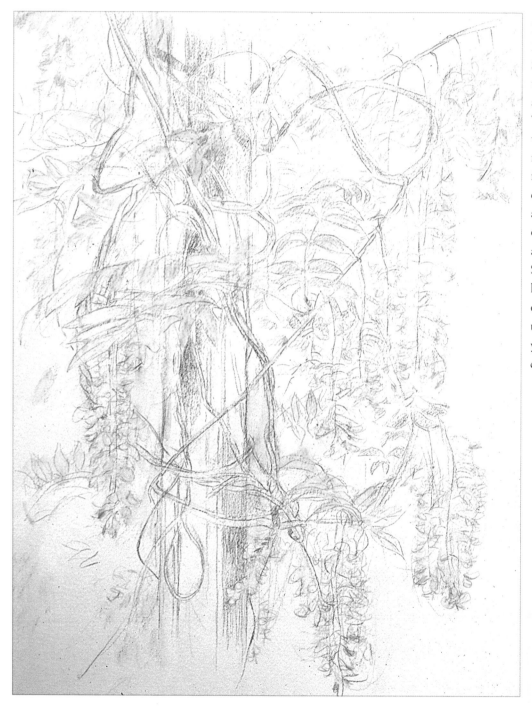

REDRAWING & FOCUS - COLORS : [3] LIGHT MAGENTA [9] SAP GREEN [10] NOUGAT

Sharpen the hanging flowers with linework using the point of [3]. Here, flower stems and some leaf edges were produced with [9]. These lines appear and disappear as they weave in front of, or behind, shapes. [10], a medium light warm color is excellent for the fine woody branches, and you will enjoy discovering how these interweave with one another. It is quite possible now to enjoy the overlaying and development of such detail, as it is supported by the drawing below. Some shading with hatching and cross-hatching creates solidity and the beginning of texture. Erasing of this new linework, using a putty eraser, is relatively easy, so you can draw with confidence, knowing changes can be made.

CAUTION

Continue to apply the color with some care, as the Artists quality pencils contain much pigment and become more powerful on wetting. Use restraint and stop before this stage becomes overworked.

SECOND WETTING

Now again, soften the painting by wetting, albeit in a more restrained fashion. The Sap Green was particularly effective, increasing the density and smoothing the textures of some of the small leaves. The direction of brush stroke when wetting is important here. In the flower head, for example, run a wet brush along the length of the central green stem. The color thus softens and darkens but does not run to the degree it would interfere with the blossom.

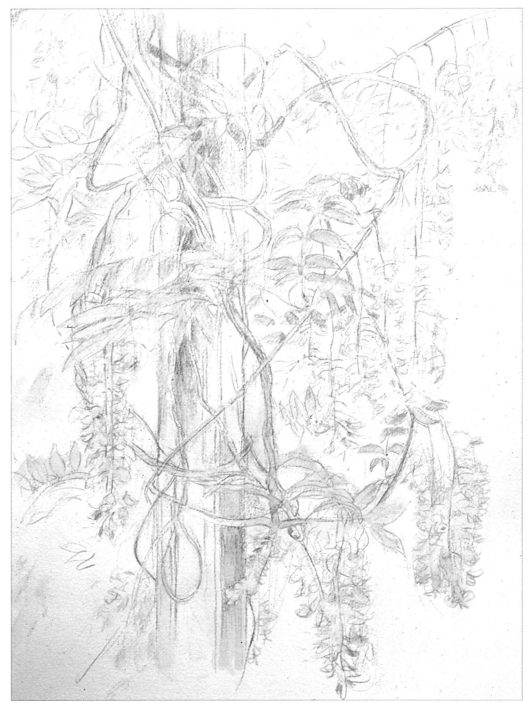

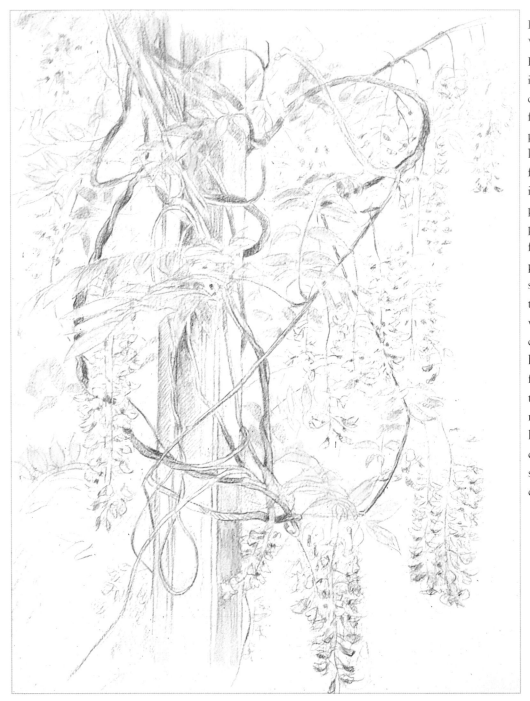

FINAL DRAWING - COLORS : [11] BORDEAUX WINE RED [12] SEPIA [13] JUNIPER GREEN
Revisit the flower heads using [11]. It is impossible and unwarranted to draw every detail here. To do so would make the flowers too stiff and hard. Instead, the patterning of dark spots rippling down their length is suggested. Some of the darker flower heads can be solidified with hatching in the same color, again in an irregular pattern, which echoes the natural balance of pigment on the flower heads. Note how the flower heads, toward the edge of the picture, are left more unfinished, suggesting softer focus. Use [12] to now add some bite to the values of the fine branches. Here I was concerned with the continuous counterchange with dark against light and light against dark edges, as stem met stem, flower, and leaf. As you won't be wetting this final application, feel free to use all necessary pressure to achieve the strength of line and depth of value required. With [13], create some dark contrast across leaf surfaces for the essential accents that bring color to life.

FINAL TOUCHES

As a final touch, use some Light Violet in the central flower heads, selectively picking out a detail here and there for extra attention. Used for shading and hatching, this cool color brings some solidity and gentle shadow to the drooping flower heads. Again, the central flower heads can receive more attention than those nearer the edges.

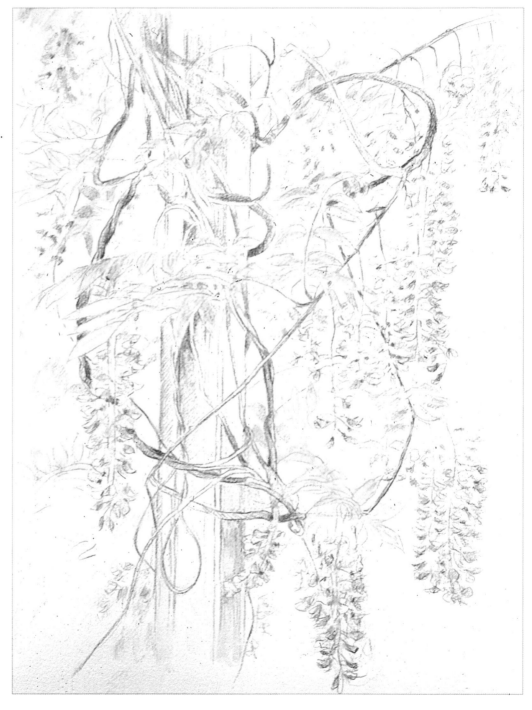

Introduction

Having worked on exercises and studies to better understand the various Line & Wash options and techniques, you need to turn your attention to putting these into practice in compositions.

The following overviews demonstrate the progressive development of a series of compositions that bring together the principle techniques covered in this book.

The first demonstration is based on Scribbling Line, which has been taken to its ultimate in an on-the-spot line and wash sketch, produced as part of a reference-gathering trip to Andalucia, Spain. When things are moving fast, you won't have a lot of time to put down the essentials or consider your approach. Instead, you have to be instinctive and scribble away as

quickly as possible. The gentleman leading the donkey was most kind and stopped for five minutes, long enough for me to grasp his essential pose, with the background added once he had gone. Color notes in the sketchbook completed the necessary reference gathering so that watercolor washes could be added later.

The demonstration in Sketching Line is interesting, for it was composed from two separate reference photographs. This is where the artist can manipulate

the composition, as opposed to the photographer who has to work with what is there. Having merged the two photographs together in the preliminary sketch, I was able to move individual aspects around a little to improve the balance and focus the eye on certain aspects, such as the villa in the top left hand corner.

In Descriptive/Suggestive Line, we see a line and wash study, completed from life and within a time restriction. This was one of a series, each of which was completed in a little over two hours. Knowing that

time was not on my side, I prepared the paper the night before, by arbitrarily adding some wet-on-wet washes throughout the background to provide a unique surface on which to work the study.

Having interrupted the purity of the surface in this way, the descriptive line drawing carried out in situ was then knitted into the structure. Watercolor was added and removed to pull the whole composition together.

After a long hot painting day on the coast, I was on my way home when these three boats came into view. While there was much more color in the scene, the strongest element was undoubtedly the yellow hull of one of the boats. In the rendering for Directional Line / Stroke, you can see that the color has been sublimated elsewhere to exaggerate this focal point.

Note the use of chinagraph, which provides a dense — yet soft — line. Being waxy, it repels the watercolor and thus remains dominant. Also note how the foreground diagonal lines flatten the sands against the vertical direction of lines on the pier and distant headland.

Colored pencils and watercolor pencils are marvellous drawing and painting tools, which are excellent for those moving into color for the first time. As with all pencil drawings, however, they can be time consuming and as such make one eager to move into working with paint. The example shown in Line or Color shows colored pencils being used solely on their own, for both line and washes.

The section is rounded off with a composition using the traditional approach of an ink line with watercolor washes. This canal scene, from Manchester, England, was painted as part of a series completed long before canals in the city were renovated to play a major part in the urban landscape. Now they are much more easily accessed and provide a wealth of inspirational material for many an artist.

MATERIALS

0.5mm Automatic 2B Pencil

2mm 2B Clutch Pencil

2B Graphite Stick

Chinagraph Pencil

Colored Pencils

Sepia Waterproof Drawing Ink

Dip Pen - Fine & Broad Pen Points

Watercolors Paints

Hake Brush

Nylon Rigger Brush

Nylon Flat Brush

Round Watercolor Brush

Kneadable Putty Eraser

Masking Fluid

Odorless Thinner

Artists Distilled Turpentine

Artist's Quality Thick Cartridge Paper

Smooth Watercolor Paper

Rough Watercolor Paper

Thick Watercolor Paper

Scribbling Line

PENCIL & WATERCOLORS

[A] 2B pencil used throughout, loosely held to ensure the scribble doesn't turn into a drawing. The line wanders around, finding silhouettes or patches of shading on which to settle. The rough surface of the watercolor paper in the sketchbook lends character to the line.

[B] Large areas of color are blocked on swiftly and decisively using a Hake brush. Using such a large brush prevents detail and demands a suggestive approach.

[C] Smaller areas of color are applied using the corner of the Hake brush head. Its light touch will not move the pencil line, and the gum of the watercolor will fix the line to the surface.

[D] Working on top of the color, use as many line textures as you can conceive to excite the eye and suggest the different surfaces.

[E] Even the areas of strongest color do not dominate the line — something for which to aim if pencil line and wash is to retain its clean look.

[F] Most linework and thus detail is focussed on the man and his donkey. The weight of the line gently diminishes as we move to the edge of the drawing.

A

B

C

D

E

F

MATERIALS

2B Pencil

Watercolors Paints

Hake Brush

Kneadable Putty Eraser

Rough Watercolor Paper

Sketching Line

PENCIL & WATERCOLORS

[A] A smooth paper was used here to prevent any disruption to the pencil line, which would have been caused by the use of a rough watercolor paper. Either thick artist's quality cartridge paper or hot-pressed watercolor paper would be ideal.

[B] Initial sketching in of gentle linework best completed with a 0.5mm Automatic pencil to prevent the line becoming heavy.

[C] White highlights or small areas of bright color may be protected from initial broad washes of paint, using masking fluid.

[D] Bold, transparent washes of watercolor paint applied wet-on-dry.

[E] The 0.5mm Automatic pencil provides absolute definition, even to the tiny accents of darkened windows. The constant lead point allows freedom in the drawing so that the complex detail can be applied fluidly and with gusto.

[F] Linework, hatching, and cross-hatching is carried out with the 2mm, 2B clutch pencil. Differences in strength and thickness of the line are controlled purely by pressure. Be imaginative in the mark, direction of stroke, and rhythms developing as you work.

[G] Foreground linework is provided by a well-sharpened graphite stick. The point swiftly wears to a soft bluntness, which produces a relatively soft line when compared to the 2mm linework directly behind and above.

[H] With masking fluid removed, the pure spot color of the poppies and bushes are now applied. Gently dilute the paint as you work into the distance.

MATERIALS

0.5mm Automatic 2B Pencil

2mm 2B Clutch Pencil

2B Graphite Stick

Masking Fluid

Watercolors Paints

Round Watercolor Brush

Kneadable Putty Eraser

Artist's Quality Thick Cartridge Paper

Smooth Watercolor Paper

Descriptive/Suggestive Line

RIGGER BRUSH, DRAWING INK, & WATERCOLORS

[A] Thick watercolor paper is stretched and pre-colored with irregular watercolor washes, eliminating the dominant purity of the white paper. Such a surface excites the imagination and is easy to work into. The gum in these early washes make subsequent colors and line physically easier to apply.

[B] Descriptive linework is applied with a nylon Rigger brush and waterproof sepia drawing ink. This color is harmonious to both the surface and subsequent colors.

[C] Powerful wet-on-wet washes create soft texture.

[D] Wet-on-dry colors have either sharp edges or are softened or lost with a damp brush.

[E] Highlights are lifted off through all layers of color. First dampened and loosened with a flat nylon brush, they are easily lifted by an absorbent tissue.

[F] Even in the darkest areas the line remains dominant.

[G] Background shapes are simplified and abstracted so as not to impinge on the complexity of the figure study.

A

B

C

D

E

F

G

MATERIALS

Nylon Rigger Brush

Hake Brush

Nylon Flat Brush

Sepia Waterproof Drawing Ink

Watercolors Paints

Thick Watercolor Paper

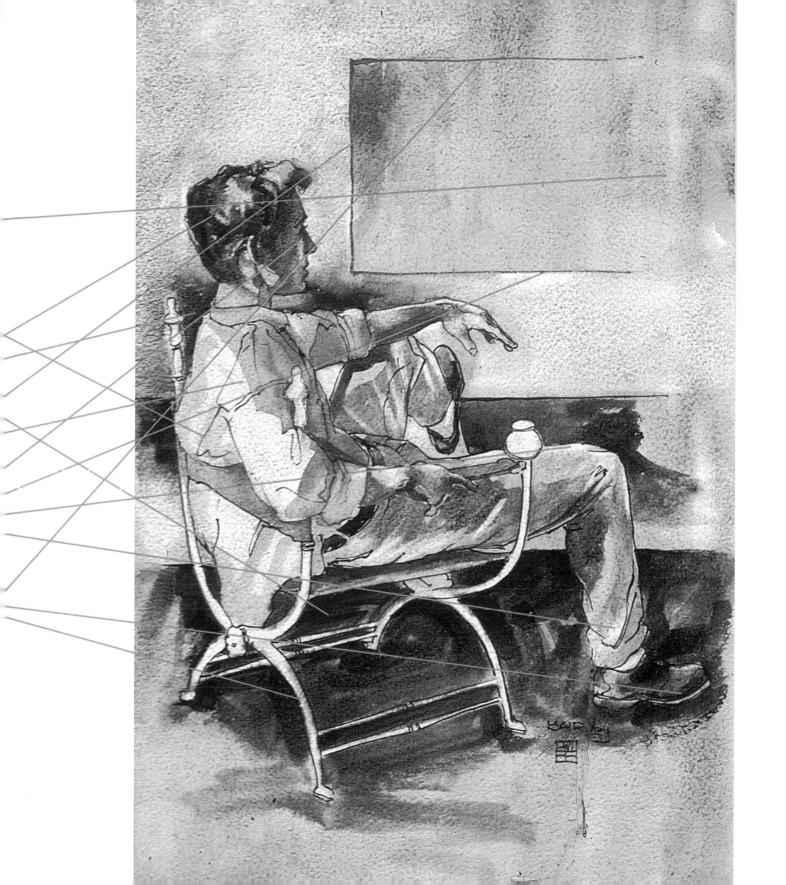

Directional Line/Stroke

CHINAGRAPH PENCIL & WATERCOLORS

[A] Hot-pressed watercolor paper provides a smooth surface for the chinagraph pencil lines and strokes.

[B] Start with the newly sharpened point of the chinagraph, to provide fine sharp linework.

[C] Linework automatically progressively softens as the pencil is allowed to become naturally blunted.

[D] Hatching provides solidity and texture and its weight is varied according to its depth into the painting.

[E] Irregular directional cross-hatching builds up structure and tones.

[F] Simple parallel hatching gives soft body, but no form to distant silhouette.

[G] Vary pressure on the lines, starting heavily and easing off as line is drawn.

[H] Directional hatching moves around the form of the hull.

[I] Wash colors are resisted by the waxy quality of the chinagraph linework. Reduce the intensity of the color everywhere except on the focal point, the yellow boat.

MATERIALS

Chinagraph Pencil

Watercolors Paints

Round Watercolor Brush

Hot-pressed Watercolor Paper

A

B

C

D

E

F

G

H

I

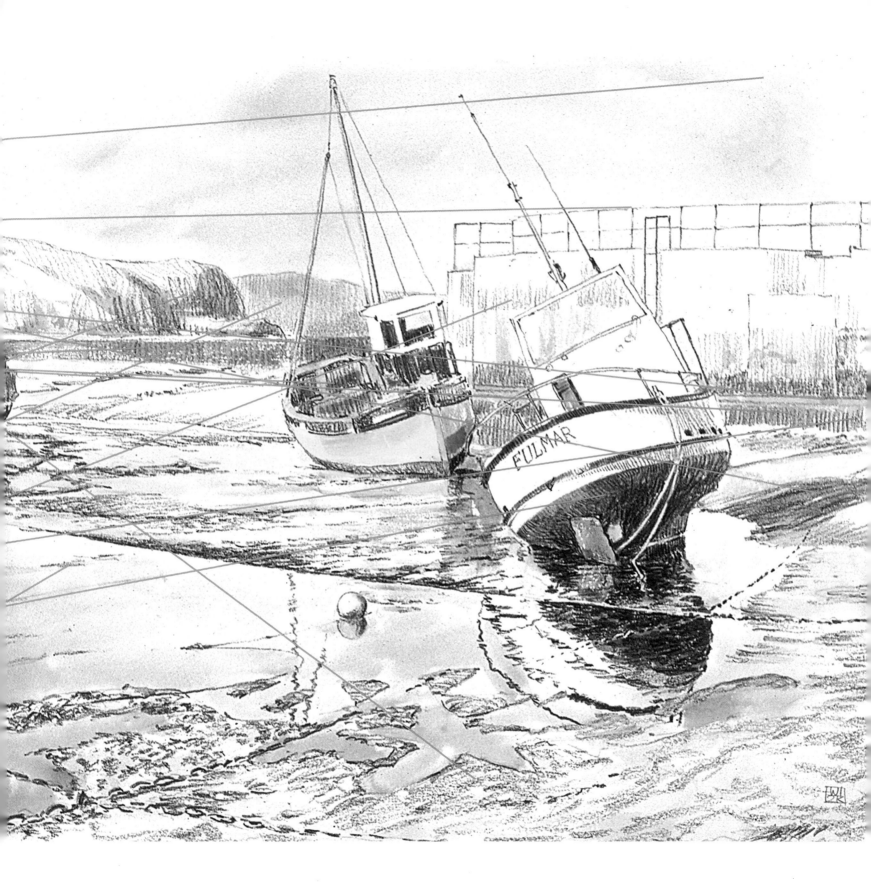

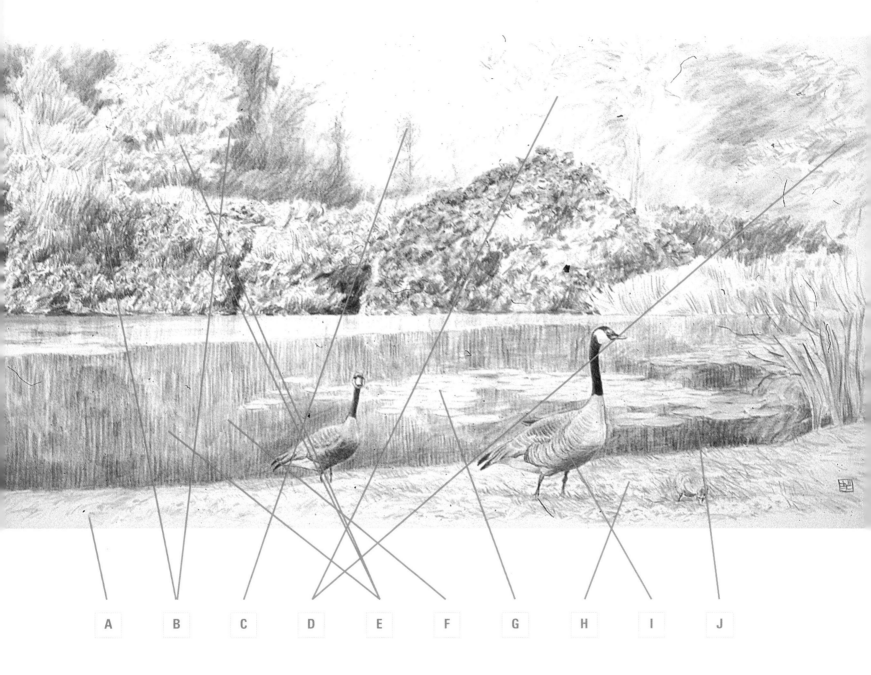

A B C D E F G H I J

Line or Color?

COLORED PENCILS

[A] Paper thickness and type affects quality of mark on the surface. Choose as smooth a surface as possible, such as the hot-pressed watercolor paper used for this composition.

[B] Heavy pressure produces dense colors. Hatching, useing shoulder of pencil or its point, depending on required focus.

[C] Color mixing — blue over greens causes recession.

[D] Gentle pressure produces light colors. Varying direction of strokes makes for an exciting visual texture.

[E] First highlight layers blended into the surface with a thinner, such as odorless thinner or artist's distilled turpentine or even a colorless correction marker. Colors merge, but don't spread as much as when wetting watercolor pencils.

[F] The first layer being fixed to the paper with a thinner allows for subsequent layers to be removed with a kneadable putty eraser, enabling undercolor to show through.

[G] Certain areas can be burnished - working a layer of white over a color to create a tint that flattens the color over which it is worked.

[H] Strokes of color produce a pattern. Distance between lengths of each stroke produces textures that carry the eye, not unlike the paint strokes in a work by Van Gogh.

[I] Dense hatching or working of the surface produces soft color mixing. No black here - simply colored grays created by the overlapping and visual mixing of colors.

[J] Color mixing — red under green creates colored grays. Strong downward strokes create the movement, which suggests reflection and the strong dark texture against which the lighter grass can contrast.

MATERIALS

Colored Pencils

Odourless Thinner

Artists Distilled
Turpentine

Kneadable Putty
Eraser

Hot-pressed
Watercolor Paper

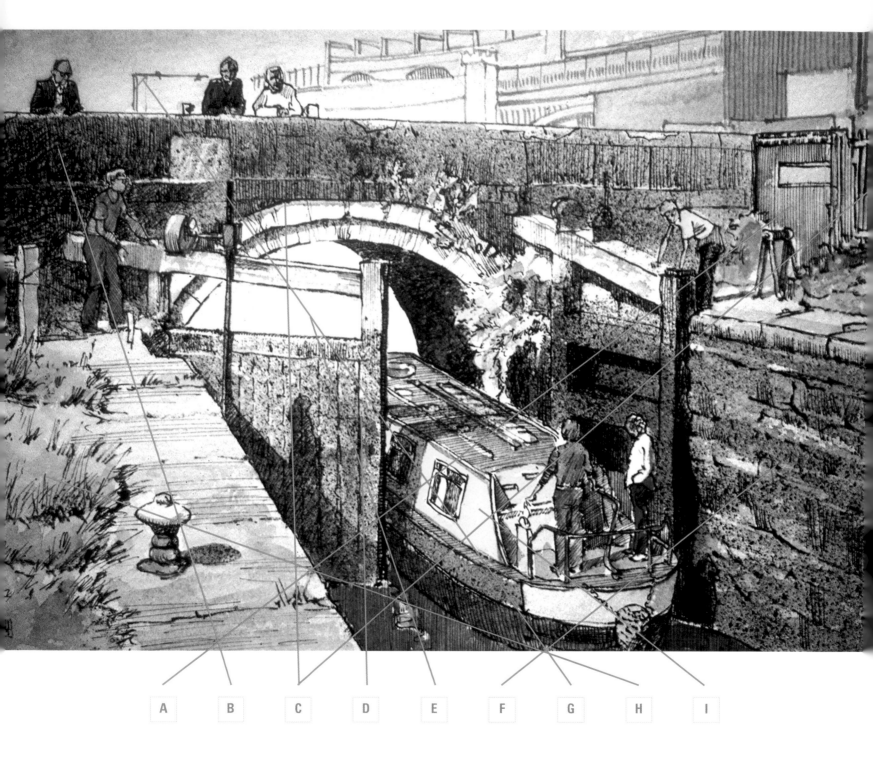

A B C D E F G H I

Line or Color?

DIP PEN, INK, & WATERCOLORS

[A] Dip pens provide fine hatching that can be laid swiftly.

[B] This hatching can be gradually overlaid (cross-hatching) to build tone and gentle texture.

[C] Broader pen points provide accent and suggest shadow.

[D] Ink sprayed from the bristles of an old toothbrush suggest solidity and darken values.

[E] It is essential that some areas are left as clean color to establish a contrast for the ink textures. Filling every space results in a dead painting.

[F] Small areas can be protected from the sprayed ink using masking fluid.

[G] Large areas are protected from spray using paper, cardstock, or plastic masks.

[H] Hatching may be kept loose, even when using a pen point.

[I] Colors benefit from being kept simple and clean, applied in one layer only. All the texture and tone is created by the ink line texture.

MATERIALS

Dip Pen - Fine & Broad Pen Points

Waterproof Drawing Ink

Watercolors Paints

Round Watercolor Brush

Masking Fluid

Watercolor Paper

ART TECHNIQUES FROM PENCIL TO PAINT
by *Paul Taggart*

Based on techniques, this series of books takes readers through the natural
progression from drawing to painting and shows the common
effects that can be achieved by each of the principal media, using a variety of techniques.

Each book features six main sections comprising of exercises and tutorials
worked in the principle media. Supportive sections on materials and tips,
plus color mixing, complete these workshop-style books.

Book 1
LINE TO STROKE

Book 2
LINE & WASH

Book 3
TEXTURES & EFFECTS

Book 4
LIGHT & SHADE

Book 5
SKETCH & COLOR

Book 6
BRUSH & COLOR

A C K N O W L E D G M E N T S

There are key people in my life whom have inspired me over many, many years,
and to them I extend my undiminishing heartfelt thanks.
Others have more recently entered the realms of those in whom I place my trust and I am privileged to know them.
Staunch collectors of my work have never wavered in their support,
which has enabled me to continue to produce a body of collectable work,
along with the tutorial material that is needed for books such as this series.
I will never cease to tutor, for the joy of sharing my passion for painting is irreplaceable
and nothing gives me greater pleasure than to know that others are also benefiting from the experience.

I N F O R M A T I O N

Art Workshop With Paul Taggart is the banner under which Paul Taggart offers a variety of learning aids,
projects and events. In addition to books, videos and home-study packs, these include painting courses,
painting days out, painting house parties and painting holidays.

ART WORKSHOP WITH PAUL

Log on to the artworkshopwithpaul.com website for on-site tutorials
and a host of other information relating to working with
watercolors, oils, acrylics, pastels, drawing and other media.
http://www.artworkshopwithpaul.com

To receive further and future information write to:-
Art Workshop With Paul Taggart / PTP
Promark
Studio 282, 24 Station Square
Inverness, Scotland
IV1 1LD

E-Mail : mail@artworkshopwithpaul.com

A R T W O R K S H O P W I T H P A U L T A G G A R T
Tuition & Guidance for the Artist in Everyone